LAURIE SIMMONS

The Music of Regret

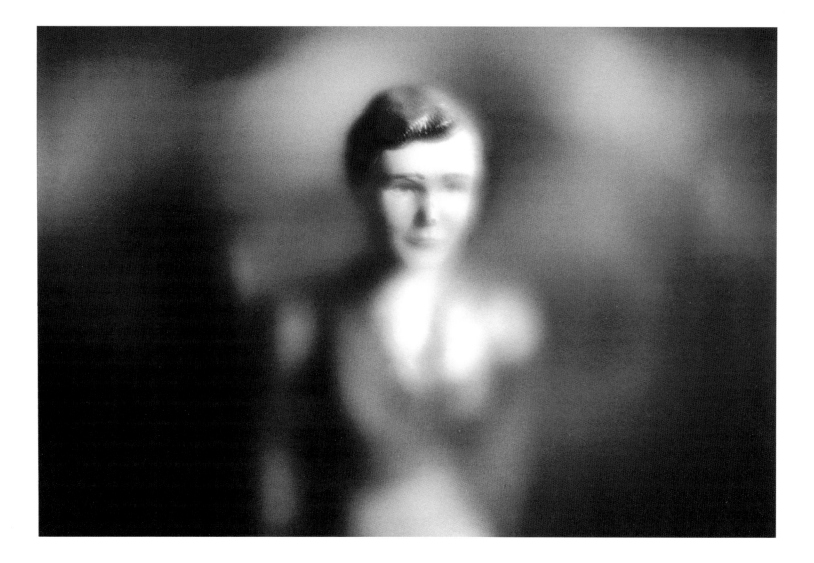

Untitled / Woman's Head. 1976. 8⅝₁₆ x 13⅜ in.

LAURIE SIMMONS

The Music of Regret

JAN HOWARD

THE BALTIMORE MUSEUM OF ART

Published in conjunction with the exhibition
"Laurie Simmons: The Music of Regret"
The Baltimore Museum of Art
May 28–August 10, 1997

The exhibition and publication were made possible through the generous support of
The Andy Warhol Foundation for the Visual Arts. Additional support was provided
through the National Endowment for the Arts, a federal agency, and the Museum's
Alvin and Fanny Blaustein Thalheimer Exhibition Endowment Fund.

Front cover: *Black Bathroom, April 16, 1997*. 1997. 30 x 40 in.
Back cover: *New Bathroom / Woman Kneeling / First View*. 1979. 3⅜ x 4¹³⁄₁₆ in.
All works by Laurie Simmons copyright ©1997 Laurie Simmons

Printed and bound in Italy

The Baltimore Museum of Art
Art Museum Drive
Baltimore, Maryland, U.S.A. 21218-3898

CONTENTS

ACKNOWLEDGMENTS

It is with enormous pride that we present "Laurie Simmons: The Music of Regret." The Baltimore Museum of Art is committed to serious consideration of the art of our own time, and it is this commitment that led us to focus on the inventive and compelling work of Laurie Simmons. We are certain that this exhibition and publication will inspire renewed critical deliberation of this artist's thoughtful and creative engagement with new visual forms and significant contemporary ideas. This art is, in turn, serious and witty, bold and muted, private and public. It contains the world and yet invites intimate personal communication, as the best art always does.

The realization of "Laurie Simmons: The Music of Regret" is to a large degree due to the purposeful resolve of Jan Howard and Brenda Richardson, who together shared an absolute conviction about the importance of Simmons's work and the timeliness of this exhibition and book. Above all, I want to thank Jan for the extraordinary exhibition she conceived and implemented. She has worked with exceptional dedication to forge the most meaningful presentation possible of an artist's work that is highly esteemed in the international art world but still not widely known among the larger American public. Putting the art and artist first, she determined to create an exhibition and book that would reflect this work with fidelity and integrity. Working closely with Simmons, Jan has achieved her goal while sustaining to the highest standards her many other responsibilities at the Museum.

As with every curatorial activity at the BMA, Brenda Richardson guided the project through all its vicissitudes, supporting Jan as colleague and friend. Brenda collaborated with Jan and the artist in selecting the exhibition catalogue's literary contributions, and she worked diligently as the book's editor, thoughtfully sharing ideas and editorial guidance in steering Jan's text to completion.

For her part, Laurie Simmons has been the ideal subject. She has participated fully in the project from the outset, giving freely of her time and energy. Over the three years since Jan Howard began working on the exhibition in the spring of 1994, the artist has never hesitated to accommodate a request, whether it was for a studio visit or to answer myriad questions by telephone. Whatever work Jan wanted to look at in the studio, Simmons made available; she was extremely generous in sharing thoughts about her art, and Jan found the working experience with the artist both pleasurable and enriching. Simmons never intruded unasked, and cooperated with admirable flexibility as the project unfolded (not always as planned). She has been a model of artist/curator collaboration and we are extremely grateful to her for the trust she has evidenced in our staff and our Museum. We are very proud that Laurie Simmons granted to The Baltimore

Museum of Art the privilege of hosting this substantial and important exhibition at a pivotal moment in the development of her work.

We were extremely fortunate to have from the inception of the exhibition the support of the artist's gallery representatives, Janelle Reiring and Helene Winer at Metro Pictures. Janelle and Helene and their staff were of invaluable assistance in locating artworks for the exhibition and in facilitating loans. At Metro Pictures, we especially want to acknowledge Tom Heman for his prompt and efficient response to many requests, and Jeff Gauntt for being so helpful in providing photographic reproductions. We also want to thank the artist's studio assistant, Helen Rousakis, who provided support throughout the project, retrieving information and art alike, and in every way easing Jan's efforts. Leslie Miller of The Grenfell Press, New York, worked in close collaboration with the artist and with Jan to design a book entirely compatible with Simmons's sensibility.

On behalf of the Museum, I want to express special thanks to Garrett Kalleberg, Susanna Moore, and John Waters, who permitted us to include their literary art in our book, thereby enriching the perspectives from which we consider Simmons's visual art.

The Museum is deeply indebted to The Andy Warhol Foundation for the Visual Arts, whose generous support was instrumental in realizing the exhibition. At a time when it seemed almost certain that we could not sustain the project, the Warhol Foundation responded to our fervent appeal. We asked the Foundation to help make it possible for museums like ours to continue to present the work of deserving mid-career contemporary artists whose art we believe in, but for which we are increasingly having trouble finding support and audience. The Warhol Foundation's positive response should be seen as enormously invigorating for artists and museums alike. We extend our sincere thanks to Foundation President Archibald L. Gillies and Program Director Pamela Clapp.

We also received a grant from the National Endowment for the Arts which, despite the adverse sociopolitical climate, continues to support worthwhile contemporary art and artists. The imprimatur of the NEA is all the more meaningful under current circumstances, and we are very grateful to Jennifer Dowley, Director, Museums & Visual Arts, and David Bancroft, Museum Specialist, for seeing our application successfully through the grant process.

As always, we have had the full support of the Trustees of the Museum in this undertaking, and it is a pleasure to express our thanks to Constance R. Caplan, Chair, and to every member of the Board. All of the Museum's Trustees consistently demonstrate confidence in the BMA staff and lend their encouragement to our efforts, for which we are very grateful.

Numerous staff members at the Museum gave special attention to this project. In

the Department of Prints, Drawings & Photographs, Jan's colleagues were especially supportive. Jay Fisher, Curator, and Susan Dackerman, Assistant Curator, both read Jan's manuscript, offering valued criticism at an early stage. Regan Tuder, Secretary, and Janice Collins, Preparator, contributed substantially as well, as did Kimberly Schenck, Associate Paper Conservator. Debora Wood, Jan's volunteer assistant, faithfully compiled material for the book's bibliography. Staff members throughout the Museum who have played particularly critical roles in realizing the project include Peter Trippi, Director of Major Gifts, who worked tirelessly to secure financial support for the exhibition; Frances Klapthor, Associate Registrar, who managed the loans for the exhibition with grace and efficiency; Alison Cahen, Assistant Director, Public Relations, who dedicated herself to furthering media awareness of the exhibition; Karen Nielsen, Director of Design & Installation, who worked closely with the artist and curator on the exhibition's installation, demonstrating her usual creativity and good humor; and, in Publications, Audrey Frantz, Director, and Lisa Pupa, Assistant, who guided this book to completion with attentiveness and skill.

On Jan Howard's behalf, I want to express warm thanks to Laurie Simmons's husband and daughters, Carroll Dunham and Lena and Grace Dunham, for their support and understanding. And, above all, Jan expresses her gratitude to her husband and daughter, Dennis and Kathan Teepe, for their loving encouragement and patience throughout these years when she has often had to give priority attention to this exhibition and book.

ARNOLD L. LEHMAN
Director, The Baltimore Museum of Art

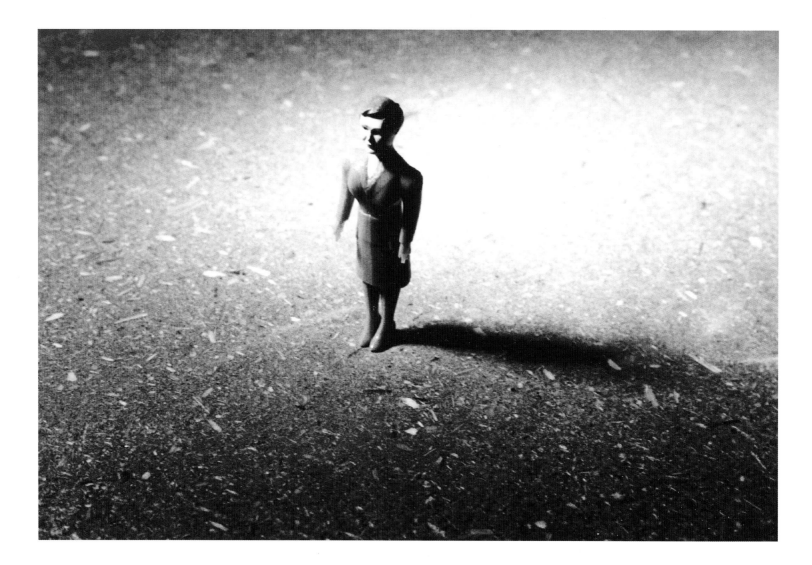

Untitled. 1976. 8 x 12 in.

PREFACE: "WITHIN WITHIN WITHIN"

Laurie Simmons adopted miniatures and dollhouse-scaled rooms as the initial field of action for her earliest mature work. She was not at that time familiar with the tradition of sand-play therapy, "the practice of giving a patient numerous dollhouse-size objects—houses, toys, figurines, animal miniatures—and a tray of sand in which to arrange the objects into a tableau."[1] Having patients, especially disturbed children, act out with dolls and toys has become a staple technique in certain forms of psychotherapy, in which sensitive observation of the patient's choices and non-verbal narrations can reveal significant information. Simmons's choice of imagery may well reveal significant psychological information about her, but in the mid-1970s when she began her "Interiors," she was simply using the materials she had at hand.

As it happens, the miniature and the dollhouse carry layered social, psychological, and metaphorical meanings. Those meanings are explored with telling intellectual scope in scholar-poet Susan Stewart's *On Longing*:

> The dollhouse . . . represents a particular form of interiority, an interiority which
> the subject experiences as its sanctuary (fantasy) and prison (the boundaries or
> limits of otherness, the inaccessibility of what cannot be lived experience). . . .
> Worlds of inversion, of contamination and crudeness, are controlled within the
> dollhouse by an absolute manipulation and control of the boundaries of time and
> space. . . . Unlike the single miniature object, the miniature universe of the doll-
> house cannot be known sensually; it is inaccessible to the languages of the body
> and thus is the most abstract of all miniature forms. Yet cognitively the dollhouse
> is gigantic.[2]

Simmons designed and built her dollhouse-sized sets, choosing the kitchen and the bathroom for most of her drama's scenes, and cast as her doll-actress a miniature adult female figure. At risk of engaging in simplistic psychobiographical interpretation, it is nonetheless difficult to avoid seeing the artist's choice of this figure as representing her own mother—the one person her child/adult unconscious mind might most want to contain and thus control.

Although feminist motivations have been assigned to Simmons's choices of subject matter, the implosive emotional intensity of these early "Interiors"—as well as many of the subsequent series—belies the cerebral sociopolitical intentions often associated with the artist's images. Feminist convictions are evident in the work, but there also seems to be something deeper and less absolute that compels this art. Simmons is

a voracious and sophisticated reader, unusually attuned to the psychological dynamics of family and other interpersonal relationships, and she acknowledges drawing heavily on autobiography and memory for the content of her work.

The revelations of body language in Simmons's photographs, whether in the "Interiors" and "The Big Figures," the somewhat later "Underwater" and "Ventriloquism," or in the more recent "Walking and Lying Objects" and "The Music of Regret," reinforce an introspective reading of the work. The characters in these photographs, alone or in groups—and except for the portraits of ventriloquists and their dummies, Simmons rarely depicts couples—signal their isolation and silence. The tiny toy dolls and child-sized dummies she has chosen to photograph are plastic or wood and have neither sight nor voice nor the power of movement. Even when the artist photographs real people, she effectively blinds and mutes them by posing them underwater or, in *Jimmy the Camera*, engulfing her model in a constructed full-body mask that leaves him turtlelike, with only his legs free to move (just as with the disembodied doll legs that appear in all the other "Walking and Lying Objects"). There is in certain of Simmons's scenes a suffocating silence, a constriction of time and space, an intensely inward sensibility. To many viewers, especially women perhaps, there is nothing at all that's funny about these pictures. Even the nostalgia that infuses them is captivatingly mournful.

> That the world of things can open itself to reveal a secret life—indeed, to reveal a set of actions and hence a narrativity and history outside the given field of perception—is a constant daydream that the miniature presents. This is the daydream of the microscope: the daydream of life inside life, of significance multiplied infinitely *within* significance. . . . Occupying a space within an enclosed space, the dollhouse's aptest analogy is the locket or the secret recesses of the heart: center within center, within within within. The dollhouse is a materialized secret; what we look for is the dollhouse within the dollhouse and its promise of an infinitely profound interiority.[3]

It is not likely that Simmons comprehended the psychosocial implications of the choices she made as she moved her life and her work forward over time. After all, most of our choices are made as much by chance and intuition as by informed directionality. Just the same, Simmons's art is charged with personal meaning, intimate in its reflections of the artist's emotional depths and biases. Longing, desire, and regret hibernate in Simmons's art, and the strategies the artist has adopted to express these amorphous and mostly unformed (if not unconscious) emotions have taken the form of enigmatic narratives in photographic works that are—like the subjects of Stewart's

book—mostly miniature or gigantic. Her collection of toys and dolls and fragments of interior furnishings and decor is the inventory of souvenirs out of which she builds collective remembrances.

Deconstructing Marcel Proust's epiphany in *A la recherche du temps perdu,* literary scholar Roger Shattuck defined the power of memory:

> Proust set about to make us *see time*. . . . Merely to remember something is meaningless unless the remembered image is combined with a moment in the present affording a view of the same object or objects. Like our eyes, our memories must see double; these two images then converge in our minds into a single heightened reality.[4]

A memory from the past is linked to a present experience in such a way that we "see double"—past and present simultaneously—so that time itself becomes visible. Scientists specializing in the biology of memory explain: "[I]t is now clear that we do not store judgment-free snapshots of our past experiences but rather hold on to the meaning, sense, and emotions these experiences provide us. . . . What has happened to us in the past determines what we take out of our daily encounters in life. . . ."[5] In other words, memory is not just "the way we were"; it's the way we are and the way we will be. Memory is all, memory is life, memory is autobiography. It is within this ambiguous arena where memory plays—and from the perspective of her own knowledge of memory's power to elicit idiosyncratic reverie and feelings on the part of herself and her viewers—that Laurie Simmons has forged her art.

<div align="right">

BRENDA RICHARDSON
Deputy Director for Art and Curator, Modern Painting & Sculpture
The Baltimore Museum of Art

</div>

NOTES

1. Dee Wedemeyer, "His Life Is His Mind," *The New York Times Magazine*, 18 August 1996, p. 25. **2**. Susan Stewart, *On Longing: Narratives of the Miniature, the Gigantic, the Souvenir, the Collection* (Durham and London: Duke University Press, 1993; first published by Johns Hopkins University Press, 1984), pp. 63, 65. **3**. Ibid., pp. 54, 61. **4**. Roger Shattuck, *Proust's Binoculars* (Princeton University Press, 1983), pp. 46–47, quoted in Daniel L. Schacter, *Searching for Memory: The Brain, the Mind, and the Past* (BasicBooks, a Division of HarperCollins Publishers, Inc., 1996), p. 28. **5**. Schacter, op. cit., pp. 5–6.

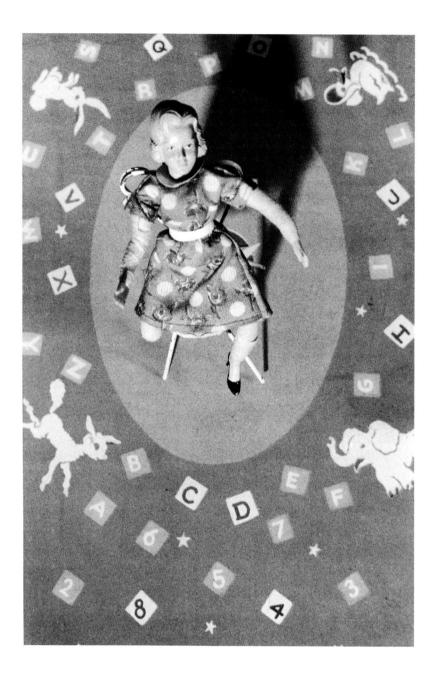

Mother/Nursery. 1976. 7¹³⁄₁₆ x 5¼ in.

PICTURING MEMORIES

. . . I'm making work about memory. And not my own personal autobiographical memory, but more like an exploration of memory and history. It's not as an exorcism of the past, but rather as an honest point to begin an external dialogue. [1]

Laurie Simmons pictures memories primarily in photographs. One of photography's main functions is an aid to memory. But Simmons does not use the medium, as most of us do, to record life's everyday and sometimes retrospectively memorable moments for future reference. Instead, she refers to memories to find the characters and sets for the scenes she creates for the camera. In the 1970s Simmons was at the forefront of a new generation of artists pursuing the uncommon artistic tradition of staging fictional scenes to be photographed. Raised in a camera-based world of television, advertising, and films, these artists had become astute observers of society as presented through processed and manipulated images. By inventing information through their photographs in response to the images that surrounded them, Simmons and others drew attention to the impact of the media on our conception of reality.

Simmons, born in 1949, routinely draws her imagery from the seemingly insignificant memories of her childhood and adolescence on suburban Long Island. Many of these memories involve images and ideas as filtered through the media. By focusing on the most familiar or the quirkiest portrayals of clichéd roles and fantasies, she reflects the very particular social and cultural patterns that applied during her youth. In the images she creates and in the style, pattern, and color of the furnishings and clothing pictured in her photographs, she clearly references the time, place, and social context of her upbringing—1950s–1960s suburban middle-class America.

Simmons pictures memories common to many, but she does so from a personal point of view. At a glance her subject matter seems as lighthearted as its popular-culture references, yet the images almost always ultimately disclose disappointment, longing, sadness, or regret. Current research on memory suggests that emotion is determinative in prioritizing memory. Rather than records of events, memories are constructions that record our interpretations of events. Emotions determine how we experience daily occurrences and how we categorize them for storage—as part of an era in one's life, as a routine happening, or, more rarely, as a fragment of a specific event. The greater the emotional response to an experience, the greater the detail with which it is remembered or, conversely, perhaps more deeply repressed. Even that which is repressed can find expression through disguise in conscious awareness, as is the case in dreams and in daydreams, for instance. We construct memories unconsciously by selecting pieces of

information from various levels of autobiographical knowledge and reassembling them into a unique narrative. Sometimes our emotions and intellect bring together unrelated bits of information, or we intersperse fantasy and reality to formulate a memory. We are in constant dialogue with memories and as we bring new knowledge to them, we continue to revise them.[2] Simmons's work suggests the enduring influence of many ostensibly amusing or nostalgic childhood memories.

Like memories, Simmons's photographed scenes are constructions. She usually stages her photographs in her studio from a large inventory of collected props, toys, and other found objects. Dolls, ventriloquists' dummies, mannequins—and occasionally even people—act out stereotypical human roles and fantasies. Marked by intentional dislocations and unexpected conjunctions, the non-linear narratives in the photographs echo those of memories and dreams. Inverting the medium's long-standing (though illusory) synonymity with truth, Simmons reveals truths through her fictions. The viewer is conscious that these are assembled images, yet it is possible to suspend disbelief and see these contrived arrangements as familiar, credible worlds. The nostalgic quality of her photographs leads viewers into a consideration of their own pasts. By constructing images of memories both personally and collectively resonant, Simmons shares the dialogue about their true content and meaning with her audience.

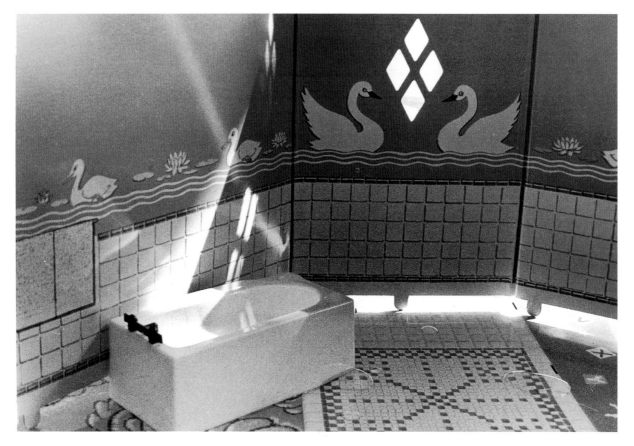

Bathroom IV. 1976. 8¹⁄₁₆ x 11¹⁵⁄₁₆ in.

*I found a toy store that was going out of business in a town in the Catskills called
Liberty. I went up to an attic, and they were selling everything they had. It was like
a strange dream. There were toys all over. They were boxed and unopened: toys that I'd
had as a child, toys I'd gotten for Christmas—the same dollhouse, the same dolls,
board games, tea sets. Not just similar—the very same brands and boxes that I had
played with. So I started buying this stuff.... Then I found an old general store, and
in the back of the store I found wallpaper, rolls and rolls of wallpaper. Like the stuff
you'd seen, maybe not at your house, but at your aunt's house or at a friend's house.
... I didn't know that I would ever use it in my art, but nevertheless I knew it inspired
me, and I carted it with me wherever I went, thinking I would put it to use sometime.*[3]

Like the *petites madeleines* of *Remembrance of Things Past*, the toys and wallpaper triggered
powerful childhood recollections for Simmons. Her purchases were made shortly after
completing her B.F.A. in 1971 at the Tyler School of Art, Temple University, outside
Philadelphia. She was living on a commune in upstate New York, where she was
influenced by the "fierce feminism" of a childhood friend who was living nearby in a les-
bian commune. These toys, conjuring up memories of girls' lives in the 1950s and the
women's roles they were expected to grow into, were particularly contrary to feminist
politics of the time. Feminists in the early seventies were forging expanded roles for
women outside the home and assertively seeking identities independent of marriage,
children, and domestic responsibilities. The new women's movement challenged the
marketing of toys exclusively for one sex, as well as the stereotyping inherent in media
representations of women. The contrast between the restricted lifestyle the toys evoked
and the freedom women were pursuing is just the kind of contradiction the mind retains
as memory in an effort to understand it.

Simmons could not have predicted in 1972 that the toys and wallpaper she bought
in the Catskills would be used as the subject matter of staged photographs, but she rec-
ognized their potential as materials for art. Her junior year was spent at the Temple
University in Rome where she cast dolls and doll parts in fiberglass, creating disturbing
works that looked like scarified babies uncovered from an archaeological site. While liv-
ing on the commune in New York State she had turned to an anti-establishment, folk tra-
dition of barn door painting in a continuation of the unconventional approaches to art
making that she pursued at Tyler. Sculpture was and remains a fundamental occupation
for Simmons, but she was uncomfortable in the macho environment of the foundry, so
she majored in printmaking, with a minor in sculpture. Found objects were integral to
both the sculpture and prints she made at Tyler. Her prints were built up like collages,
incorporating tracings from popular-culture images and found photographs. One work

from her senior year was made up of one-by-one-inch framed prints, based on anonymous family photographs scavenged from an abandoned house. She spread the prints over the gallery floor as a gesture in the questioning spirit of the early 1970s that challenged all forms of tradition and authority.

Simmons, along with many of her fellow students, was inspired by the art and persona of Marcel Duchamp, the artist who most radically challenged the definition of what art could be. With his ready-mades he elevated found objects (most notoriously a urinal) to the status of art by signing them (not necessarily with his own name), placing them in an art context (like an exhibition), and calling them art. The incomparable Duchamp collection at the Philadelphia Museum of Art was Simmons's most important introduction to avant-garde art. *The Bride Stripped Bare by Her Bachelors, Even (Large Glass)*, 1915–1923, and *Etant donnés: 1° la chute d'eau, 2° le gaz d'éclairage*, 1946–1966, were frequent topics of discussion at Tyler. *Etant donnés* seems particularly relevant to the work Simmons later developed. It is a tableau constructed with a surrogate figure and found objects that are placed before a photographic backdrop—precisely the method Simmons would develop in staging her photographs. Perhaps still more important to her, though, were the unsettling psychological issues in the Duchamp work that, viewed through a peephole, portrays a realistic female nude with legs splayed toward the viewer.

Simmons did not study photography at Tyler; she did not consider it an art medium. But after moving to New York City in 1973 and excitedly, almost feverishly, attending art exhibitions, performances, and films, her views changed. She saw photography used in many forms of art, from Conceptual to the documentation of performances, temporary installations, and remote site-works. John Baldessari, Mel Bochner, Gilbert & George, Duane Michals, and Jan Groover were using the camera to make serial and multi-part works that she found inspiring. Contemporary fashion photography also stimulated her thinking about the potential of the medium, especially the unprecedented pictures by Helmut Newton, Deborah Turbeville, and Chris von Wangenheim. Simmons also looked at historical photography, including Alexander Rodchenko's playful images of cutout paper figures for a book of children's verse, *Samozveri*, 1926, and Surrealist photographs by Hans Bellmer of his grotesquely reconstructed dolls, and by Man Ray of posable artists' mannequins.

The wide range of approaches to photography that Simmons encountered in New York made it seem like territory open for exploration. The medium's relatively short history, in which women played major roles throughout, also contributed to its appeal. Simmons began learning everything she could about its earlier practitioners. The photographer Jimmy DeSana, her friend and neighbor, taught her black-and-white processing and printing. She photographed home interiors and table-top setups created from miniature objects, primarily the toys she had purchased in upstate New York. As she

formulated her work as an artist, she also sought out commercial assignments to support herself. She photographed paper dolls with fabric backdrops for a fabric shop advertisement. She tried out for a job doing ads for a toy store on lower Fifth Avenue and, although she was not hired, she made a number of pictures in preparation. It is difficult to distinguish these photographs from her personal experiments, so close are her methods to those of advertising. Once she embraced photography, she did not feel constrained by the kinds of techniques that were considered appropriate for art, and she adopted many aspects of commercial photography.

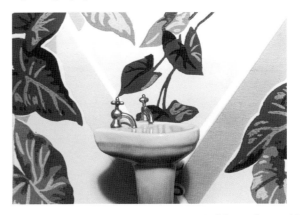

Sink/Ivy Wallpaper, 1976, the picture Simmons considers her first mature art work, combines a dollhouse sink and wallpaper in a simple arrangement. Nothing about the picture is consistent in scale. The faucets on the sink are too large, the leaves of the wallpaper are as big as the sink, the drops of water on the sink are as big as the faucets. Yet through the camera's lens this modest arrangement becomes a lifelike setting. Simmons was captivated by the magic of photography as it transformed her miniature objects. *Sink/Connecticut*, 1976, photographed in a real house, is also ambiguous in scale. The sink, shot from above, looks like a miniature. The artist is clearly testing the camera's capacity to create illusions. "The great thing about working with the photographic image is that scale becomes meaningless in a certain way. . . . [E]verything is unified within this surface. Well, that kind of ambiguity is what drew me to working with a camera in the first place. . . . I never was concerned about whether the camera tells the truth. I've always been concerned with how much it can lie and how far can I take this."[4] Watching magic tricks was an obsession for Simmons as a child, and she looked for magic shows on television. She says her earliest sexual thrill was seeing magicians sawing women in half and making them float.[5] And, like those tricks that so amazed the child, photography was also a kind of magic for Simmons. She spent hours sitting on the floor of her father's darkroom (he was a dentist who processed his own x-rays) enthralled with the images that he developed. The magic—the illusion that is not comprehended by rational thought—conveyed in photographs is of keen importance throughout her work.

Sink/Ivy Wallpaper. 1976.
4¹¹⁄₁₆ x 6⅞ in.

Simmons's first pictures of the dollhouse were a series of enchanting black-and-white bathroom views. It is a serial sequence in which she changed the arrangement of walls and bathtub and, in a Monet-like approach, photographed the bathroom at different times of day and from different angles. Sunlight streams in through the windows in varying patterns from

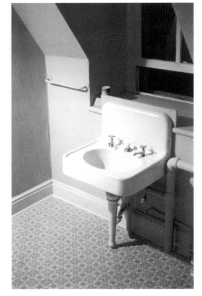

Sink/Connecticut. 1976.
7 x 4¾ in.

picture to picture, creating an overall kaleidoscopic effect. Printed in soft tones on a richly-silvered mat paper, the shadows appear to have depth and the light seems palpable. The dollhouse is transformed into a dazzling, dreamlike stage set.

A housewife doll (an unmarried woman is unimaginable in a 1950s dollhouse) entered the set when Simmons turned the camera toward the kitchen. Working in series again, she photographed the figure over and over in various positions—standing and sitting at the table, at the counter, in a corner, standing on her head with the kitchen in disarray. The mood is dramatically different than in the bathroom views. The housewife seems hysterical—an uncharacteristic portrayal of the doll among the "Interiors" that follow. She printed only one image from the series in 1976—a view of the kitchen without a doll. There is little sentiment or nostalgia in these disturbing scenes. Perhaps she found the overtly emotional portrayals too limited in their interpretation. In 1983 a selection from the series was printed in her first artist's book, *In and Around the House: Photographs 1976–1979*, published by the CEPA Gallery in Buffalo, but she did not include the most extreme view of the woman on her head.

Once Simmons began placing dolls in interiors, her pictures invited psychological interpretations. *Mother / Nursery*, 1976, portrays a doll photographed from above so that she appears small and childlike; her high heels are the only clue to adulthood. She looks up with her open arms as if crying for someone to nurture her. Through her staging of the scene, Simmons gives voice to her figures, and viewers have little hesitation investing this doll with feelings. Advertising, television, and film have programmed us to identify with any situation represented photographically, no matter how artificial. *Untitled / Woman's Head*, 1976, a close-up of a dollhouse figure in a shadowy, undefined setting, has even greater emotional pull. The photograph's soft focus is unusual in Simmons's work and gives the doll the uncanny appearance of being both a toy and a real person. The image acts as a metaphor for a woman's struggle to be visible, vital, and distinct. It is interesting to learn that many women's memories concern the issue of visibility: studies suggest that women often feel they are alone, with no one to support them or to witness their struggles.[6] The image could represent Simmons in her struggle to be recognized as an artist. The invisibility of women is a recurring theme in Simmons's work and this early picture is one of her most beautiful and poignant portrayals of the subject.

Concurrent with the "Interiors" Simmons also photographed the "Black Series." This series developed from her interest in the systemic work she saw when she first moved to New York by artists such as Hanne Darboven, Sol LeWitt, and Dorothea Rockburne. She was intrigued with the Conceptual artists' method of creating works of art according to a predetermined formula, in many cases looking to fields outside of art—such as philosophy, mathematics, and language—for their subjects. The "Black Series" grew from these strategies. Simmons applied the rules of interior decoration to

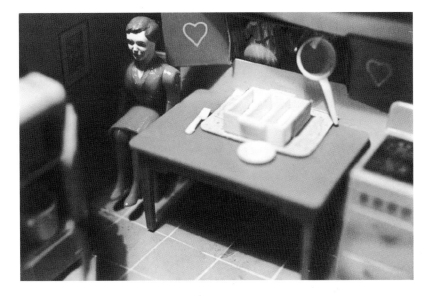

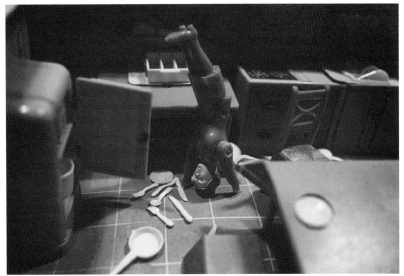

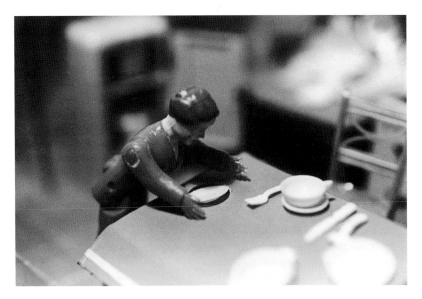

Untitled, from "Interiors." 1976. Each approx. 6 x 9 in.

art and, at the time, considered it her serious work. The pictures usually include a photographic reproduction—a postcard or an advertisement—in a complementary arrangement with dollhouse furniture or other domestic miniature objects. All were placed against a black backdrop with the camera's framing creating a room-like space.

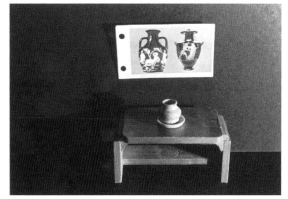

Table / Pot / Two Greek Vases.
1976. 6¼ x 9 in.

As beautiful as Simmons's early black-and-white photographs from the "Black Series" and the "Interiors" were, she longed to make images that conveyed the color she saw in the studio. Color—a certain kind of color—could cue her audience to an earlier time and evoke a particular range of emotions. She thought the "Interiors" in black and white seemed too sad. After seeing Jan Dibbets's work and learning that he relied on the corner drugstore for his color prints, she began shooting in color, processing her thirty-five-millimeter transparencies and prints at a commercial lab. Yet she felt it was her responsibility to learn the process. In January 1977 she began making her own color prints using the Cibachrome process. A technique developed in 1963 for commercial labs that produced sharp, vivid, and relatively stable color prints from color slides, Cibachrome became available in a simplified version for home darkroom use in 1975. Simmons bought one of the small processing sets that were sold to promote the use of these high-key color materials. The kit came with chemicals, a processing drum, and twenty-five sheets of four-by-five-inch paper (five-by-eight-inch paper was the largest size the drum could accommodate). At that time a number of artists were beginning to work in color photography—among them William Eggleston, Jan Groover, Lucas Samaras, and Stephen Shore. Though practical color film had been available since the late 1930s (Kodachrome sheet film came on the market in 1938, roll film in 1941, and Ektachrome in 1942), most art photographers found its unnatural color inappropriate for describing reality. With color film becoming available during the Depression, however, commercial photographers explored its advertising potential for glamourizing both products and people.[7] Color thus became more commonly associated with the

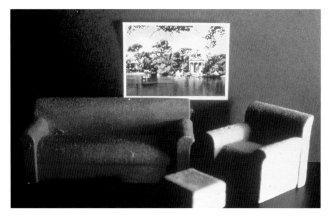

Red Couch / Gray Chair /
Borghese Garden.
1977. 3⁵⁄₁₆ x 5⁵⁄₁₆ in

artifice of commercial photography while black-and-white was perceived to be more truthful. By using the techniques and processes identified with advertising, fashion, and film, Simmons linked her work to a realm of suspended disbelief—the realm of fantasy and fiction that sustained many of her memories and longings.

Her first color pictures were for the "Black Series." In *Red Couch/Gray Chair/Borghese Garden*, 1977, a postcard of the garden serves as the proverbial painting over the sofa in a coordinated color scheme. *Worgelt Study*, 1977, contains a postcard of a period room at the Brooklyn Museum of Art and a dollhouse armchair and coffee

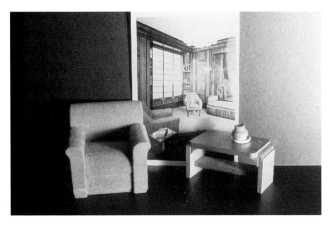

Worgelt Study. 1977.
3¼ x 4⅞ in.

table. Once photographed, the furniture appears to be part of the room pictured in the card, prefiguring a device Simmons would routinely use in later pictures. In 1978 Simmons began shooting dollhouse interiors in color. In an extended series of bathroom pictures that she photographed through 1979, she portrayed a housewife moving through the room as if the doll were an actress creating frames for a stop-action film. A beautiful aquamarine light bathing the room claustrophobically contains the doll in the space. With a housewife doll in dress and heels and bathroom fixtures brilliantly gleaming, the scene is typical of television commercials for cleaning products. As the artist sequentially repositioned the doll, the fixtures, and her camera, she mimicked the never-ending duties of the housewife.

Simmons posed dolls throughout the dollhouse, always in tight spaces, always alone, always in mundane activities. She made several images of a doll standing in a kitchen engulfed by oversized groceries. In living-room scenes a doll sits on a couch in front of the television or newspaper with a glazed expression. *Woman Reading Newspaper*, 1978, suggests an attic space, its sloping walls caving in on the doll. For *Woman/Gray Chair/Green Rug*, 1978, Simmons pointed her camera down on a small figure in a large armchair placed on a swirl-patterned carpet. Her arrangement of the scene and the angle from which she shot it project the vulnerability of a woman. Typically, Simmons's characters are portrayed in oppressive settings, and their expressions seem detached, their thoughts somewhere else. For a 1997 video, *Laurie Simmons: Filmstrip*, the artist set her photographs to music, poetry, and dialogue. The accompaniment to the "Interiors," appearing one after another on the screen, is a song from the musical *On Your Toes* that the artist listened to again and again as a teenager. The lyrics of "There's a Small Hotel" relate the happiness that comes of shar-

Woman Reading Newspaper.
1978. 3³⁄₁₆ x 4⅞ in.

ing a life together as husband and wife. The contrast between the sentiment of the lyrics and the emotional resonance of the photographs is acute.

The small size of the early color prints reinforces their intensity. The tiny three-by-four-inch images are dense with detail and pattern, made all the more extreme by the saturated Cibachrome color. These vibrant, inconsistently scaled compositions have wildly diverse sources, ranging from the "flat-footed" special effects of Ray Harryhausen in films such as *The Seventh Voyage of Sinbad*, 1958, to the early Renaissance paintings she first saw in Italy as a student. The work of Cimabue, Duccio, and Giotto profoundly impressed her, particularly the vivid, localized color, the tight compositions built up of layered elements that create a compressed stage-like space, and the use of a dual scale for figures and architecture. Religious paintings of the fourteenth century are an unexpected inspiration for Simmons's glossy, gem-like photographs reflecting memories and myths of the mid-twentieth-century homemaker.

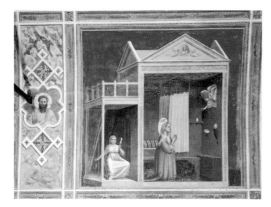

Giotto. *Annunciation to Saint Anne*. 1303–1305. Scrovegni Chapel, Padua, Italy.

The "Interiors" were constructed from an amalgam of memories. Most directly, Simmons drew from memories of her mother and other mothers she knew who worked at home, as well as of those portrayed in widely viewed television shows such as *Father Knows Best* and *The Donna Reed Show*. Certainly her pictures recall the limited roles for women that reflect clear inequities between males and females—and, more generally, broader sociopolitical and especially racial inequities—that were sharply evident in the years of her upbringing. But Simmons's dolls never clearly play the role of mother: they are never pictured with children. The artist's isolated and introspective figures are pictured at home, but absent from their families. In this regard, Simmons was perhaps drawing on memories of herself—her mother was at home, but not with her. The middle of three girls, she was the independent sibling. She found it easy to occupy herself and spent much time alone when she was young; the "Interiors" derive in part from her own memories of childhood role-playing. Simmons had a particularly strong desire as a child to become a character in her illustrated books, a fantasy that softened her loneliness. She has a particularly fond memory of Crockett Johnson's *Harold and the Purple Crayon*, 1955, in which the main character colors himself into a series of adventures. The book fueled her early desire to become an artist. Beginning with the "Interiors" and in many of the series that follow, Simmons fulfills her desire to get inside the picture.

The "Interiors" were a private activity, made with very little feedback. Simmons's first opportunity to exhibit her work came in January 1979 at the non-profit gallery Artists Space in New York. Helene Winer, then director (now co-owner of Metro Pictures where Simmons has been showing since 1981) asked Simmons to exhibit immediately after seeing the "Interiors." Simmons was initially much more comfortable with the "Black Series," though the "Interiors" gained the most attention. For many years

she played down the personal, psychological, and feminist associations of the "Interiors."

Through the Artists Space exhibition, and shortly before it, Simmons became aware of other women artists making photographs that spoke to the roles of women. Sarah Charlesworth was examining the construction of history by rephotographing the front pages of major newspapers, with the body of text omitted, in a series entitled "Modern History." The text-less masthead and photo-layout made it clear how the same issue was viewed in communities throughout the world and, most pointedly for Charlesworth, that history was being written without women. Barbara Kruger was making placards using 1940s–1960s mass media images overlaid with her own accusatory feminist texts. Sherrie Levine constructed silhouettes of past presidents from cutout images of women portrayed in fashion magazines, pointing out the power structure that reinforced the limited horizons for women. Cindy Sherman played both director and actor to stage for her own camera the female character types promoted in Hollywood, creating her untitled series of photographs known as the "film stills," 1977–1980. In 1979 Simmons discovered that Ellen Brooks was also photographing miniature dolls in tableaux. Brooks's pictures, focused on male and female relationships, also made reference to television portrayals. Both Brooks and Simmons preferred to photograph dolls rather than people in order to suggest archetypes.

Photography was crucial to the feminist response to representations of women in the mass media. Photography, less weighted down with male masters than painting and sculpture, was the language of the media. With women most frequently the subject, and men most frequently the producer, it is not surprising that women, Simmons prominently among them, were at the head of what was termed in the mid-1980s a "postmodern" media critique. Artists associated with postmodernism (Simmons is ambivalent about the term) fabricated or appropriated images from popular culture to reflect their pervasiveness and influence. As they duplicated and exploited images that already existed, these artists questioned not just the pernicious effect of popular culture but also the nature and importance of originality and uniqueness in art. The profound impact of this work, much of which made use of photography, shifted the medium from the wings to center stage of the art world.

Simmons is, in fact, generally ambivalent about labels assigned to her art, feeling that they can limit its interpretation. Though she acknowledges her work's feminist perspective and the influence of feminist artists working in the early 1970s, she does not call her work feminist art. She and many women artists of her generation saw the marginalization of feminist art and preferred moving its themes into the mainstream. Simmons also saw her work as emerging from the Conceptual currents that surrounded her in the 1970s. It was only on recent reflection that she acknowledged to herself the impact of the groundbreaking collaborative exhibition, *Womanhouse*, 1972. This project, conceived and organized by Judy Chicago and Miriam Schapiro for the Feminist Art

Program at California Institute of the Arts, transformed an abandoned home in Los Angeles into an environmental art work. Schapiro's contribution was a handcrafted dollhouse made with the assistance of Sherry Brody. The rooms were based on adult fantasies—a Hollywood bedroom, a nursery filled with nightmares, an art studio—and building the house was a way to recapture the play of childhood too quickly given up in the struggle to be accepted on equal terms with males. *Womanhouse* paved the way for the acceptance of female imagery in art, and Schapiro's piece paved the way for the dollhouse imagery Simmons developed.

The house and its interior were not subjects exclusive to women in contemporary art; artists such as Claes Oldenburg and Lucas Samaras had used the house and its rooms in the 1960s. In 1973–1974 Joel Shapiro began making small sculptures in the shape of a house, introducing metaphorical interpretations into his reductive forms. James Casebere photographed miniature interior spaces in the 1970s but, rather than using toys, he built sets for the camera from matboard and other simple materials in a metaphorical exploration of the inner self. Simmons's dollhouse, too, is a metaphor not only for a woman's world but also for an interior world. Gaston Bachelard writes that the intimacy of the spaces within the home allows us to withdraw into ourselves. It is

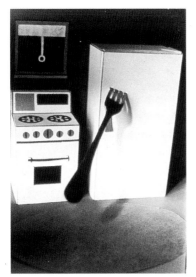

James Casebere.
Fork in the Refrigerator. 1976.
Gelatin silver print. 10 x 8 in.

the site of our childhood and the most intimate moments of our adult life and therefore the place with which many of our memories are associated. In *The Poetics of Space* Bachelard writes that "the house is one of the greatest powers of integration for the thoughts, memories and dreams of mankind." [8]

The "Interiors" elicit meaning on many different levels—poetic, art historical, personal, political, social, and psychological. Simmons stages the images to be open-ended in their interpretation; her titles are simply descriptive. The pictures contain internal—and intentional—contradictions. The space in them is claustrophobic, yet the color is joyful. The pictures are often bittersweet: they sometimes recall disappointments of the past and, simultaneously, longings for the "innocence" of early childhood. The work's paradoxes reflect Simmons's mixed emotions about her memories and feelings. "I was simply trying to recreate a feeling, a mood, from the time that I was growing up: a sense of the fifties that I knew was both beautiful and lethal at the same time." [9] A disjunctive quality threads throughout her work as a visual metaphor for the contradictions between the life we were expected to lead, the life we lead, and the life we wish we could lead. The remarkably trenchant "Interiors," as tender as they are tough, were the foundation for all the work that followed.

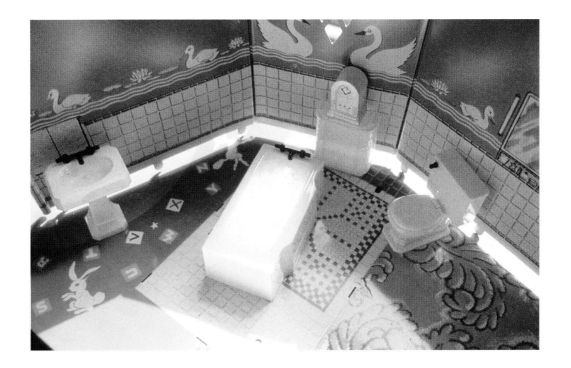

Bathroom Plan. 1978. 3³⁄₁₆ x 4¹³⁄₁₆ in.

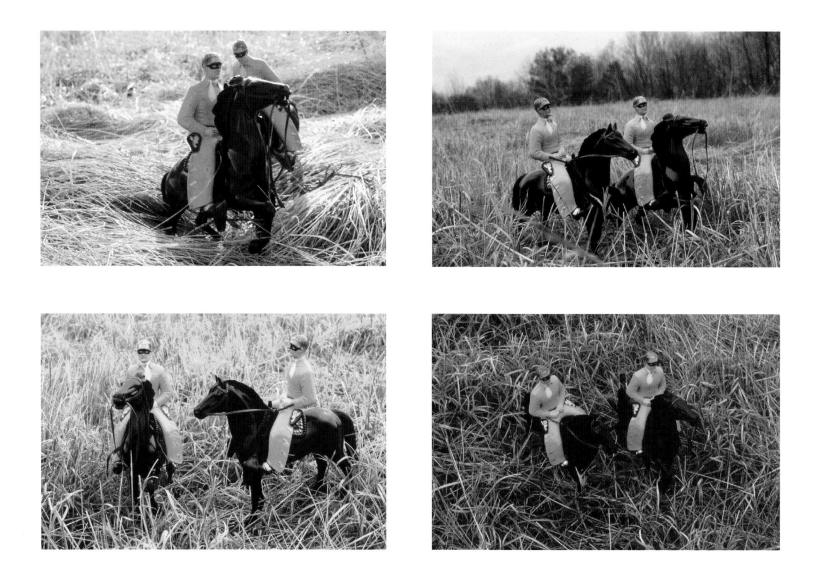

Clockwise from upper left: *Brothers/Hay*. 1979. 4¹¹⁄₁₆ x 7⅛ in.; *Brothers/Horizon*. 1979. 4¹⁵⁄₁₆ x 7½ in.; *Brothers/Aerial View*. 1979. 5 x 7¼ in.; *Brothers/No Horizon*. 1979. 5 x 7⁵⁄₁₆ in.

THE BIG FIGURES

Such cowboys dominated the TV screens in every household in the Fifties.[10]

Each body of work that Simmons has created is a response to what came before as she developed a dialogue with her viewers. To control the discourse with her audience, she moves back and forth between female and male roles, between miniature objects and life-size, between surrogates and real people, between interior and exterior worlds. Conscious that the "Interiors" might be viewed as having meaning to women alone, she was anxious to work with a male subject. In 1979, while continuing to photograph the conventionally female territory of the home, Simmons also explored its antithesis by examining the conventionally male territory of the frontier in a series entitled "The Big Figures."

Using the cowboy figures her future husband played with as a boy, Simmons staged reminiscences of television Westerns. The "big figures" (the name her husband and his brother gave to these six-inch cowboys during their childhood) were posed out-of-doors in a real landscape. Through the combination of her viewpoint and the camera's conflation of space, the elements of the landscape—rocks, trees, grass, barns, and water—all take on credible scale in relation to the figures. In a series of pictures of the "brothers," taken from varying viewpoints and in different light as Simmons loves to do, figures ride through grass nearly as tall as they are. Their multiframed portrayal animates the figures, and the unnaturally brilliant Technicolor look of the prints extends the movie reference. Her Western images portray one of the primary gender types of classic Hollywood cinema—the tough, independent, and adventurous man, not wanting or needing a home life. His characteristics are totally incompatible with those of Hollywood's ideal female who is nurturing and domestic—the role Simmons examined in the "Interiors." Simmons portrayed the men in "The Big Figures" as loners, or riding with other men, and even with a woman. The men are dressed up to go out, as opposed to the women in "Interiors" who are dressed up to stay in, alone at home though not contentedly. Simmons's homemaker has an anxious psychological dimension—she is not the film screen's ideal woman.[11] The artist's alluring pictures of the toy cowboys parallel the typically seductive representations of the character type, and her carefully fabricated scenes parallel the inventive construction of the cowboy mythology. These pictures implicitly question the tolerance and promotion of the wild-west fiction that embraces racism, violence, and paternalism as a way of life. It is more difficult to empathize with the characters in "The Big Figures" than with those in "Interiors." To a female viewer, at least, "The Big Figures" rarely transcend their fantasy world. In this series, and in later works, men are given a one-dimensional portrayal that is likely a sly, purposefully stereotypical comment by Simmons on the gender.

The ubiquitous presence of cowboys in movies and television and related toys of the 1950s and 1960s also served as the source for photographs made by Casebere and David Levinthal in the 1980s. In 1980 Richard Prince began a series based on the Marlboro Man, a cowboy used in a notoriously successful advertising campaign. His tough, seductive image is linked inextricably with smoking the manufacturer's brand of cigarettes. Prince's pictures, like Simmons's, have a double edge of acknowledging the lure of the romantic myth and concurrently questioning its venal message.

UNDERWATER AND BALLET

I was addicted to Sea Hunt, *I was addicted to Esther Williams. I always had some sort of obsession with fish, and aquariums, and bathing beauty sequences, and just that whole notion of being able to smile and breathe and move around underwater. Because whenever you go to places like Weeki Wachee, or the aquarium, or you see Esther Williams, of course, it looks like they don't have to come up for air. They have it down pat.*[12]

Simmons's memories took her to a third setting in 1979—an underwater world. She first photographed a home aquarium which, like the dollhouse, was a simulation of the real world. Most people know the tropical seas from representations in aquariums and photographs, from Jacques Cousteau's television shows to the synchronized swimmers and mermaids of Hollywood. Simmons's attraction to the abstract and painterly possibilities of photography is most evident in her aquarium pictures, a series entitled "Under the Sea." The divers, rocks, plants, and coral are formally composed splashes of glimmering color; the distortions of seeing the forms through glass and water add to their abstract appearance.

She initially photographed from outside the tank but soon had the use of an underwater Nikon, a treasured gift from a friend, which Simmons first used by dipping it into the fish tank. Then, for greater mobility, she took it into a pool with the miniature divers and other aquarium objects. While she was photographing the miniatures she happened to turn her camera on the people swimming in the pool. In the beauties and distortions of their bodies she found a surprising new subject. Simmons had unsuccessfully photographed people in setups based on the "Interiors," but had found it difficult to achieve the desired distance between herself and her subjects. Underwater she discovered a space very similar to the one she had photographed in the dollhouse, particularly in the blue bathroom pictures. Water contained the figures in space just as light

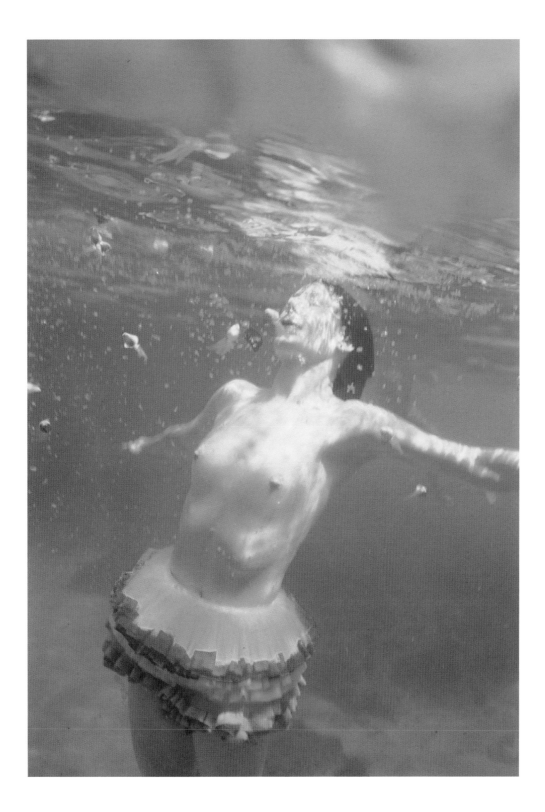

Water Ballet (Vertical). 1981. 19⅝ x 13³⁄₁₆ in.

had in the earlier photographs. The move from dolls to people was important. Though she had greater control photographing dolls, the photographs with toy subjects risked a less serious consideration. After exploring the superficial image of the movie cowboy in "The Big Figures," water provided a new interior space for reflection—a space below the surface, inviting the psychological depth characteristic of the "Interiors."

Using friends as models, Simmons directed a "Water Ballet" choreographed under the surface of various pools and the clear waters of the Caribbean. The movements she requested of the swimmers were developed by watching them improvise. So great was her concentration that she would stay underwater (held by a weight belt) for long periods of time without breathing. The underwater stage was occupied by men and women, sometimes in leotards or tutus, usually nude, acting out Simmons's directions inspired by the resplendent underwater sequences of the cinema. *Water Ballet*, 1981, portrays a woman dressed only in a tutu trimmed in bright colors. Plastic goldfish that look like rose petals float around her as she ascends near the surface. Her face and chest are bathed in light, her arms are spread, and her eyes are closed as if in ecstasy as she submits herself to the water. In *White Man Coming*, 1981, a man in a white full-body leotard and swimming cap floats off the ground in an erotic suspension of gravity. In pictures such as the "Calumny" series, 1981, swimmers voluptuously glide, tumble, and stretch, flaunting the physical, acrobatic pleasures of play and the sensuality of the water. The title "Calumny" was derived from the visual relationship of these figures to those in Botticelli's painting *Calumny of Apelles*. Simmons's nudes build on one of the great traditions in art, and especially in photography.

With the water pressure creating distortions of the body, these pictures play havoc with the idealized image of bathing beauties. The cold blue water spills over onto the swimmers, coloring their bodies with an otherworldly cast. The series is reminiscent of Turbeville's notorious "Bathhouse" photographs from the May 1975 issue of *Vogue* that had profoundly impressed Simmons. The contrived, dance-like poses of many of the swimmers echo those of Turbeville's melancholic and detached models.[13] As those models distanced themselves from the viewer with their aloofness and atmospheric setting, Simmons's models are distanced by the water. The depth and reflective quality of the Cibachrome prints are as seductive as the imagery. These larger prints (generally sixteen-by-twenty-inch and twenty-by-twenty-four-inch) lure the viewer into her underwater world.

These pictures also often convey the perils associated with the water. Bubbles released from the swimmers remind us that these are not mermaids. In *Splash*, 1980, three figures pierce the water with a violent force. *Bullet*, 1980, suggests in its title the force of the water and the danger inherent in one's encounters with it. The swimmer's limbs are thrown back as if by some kind of powerful impact. In this series Simmons

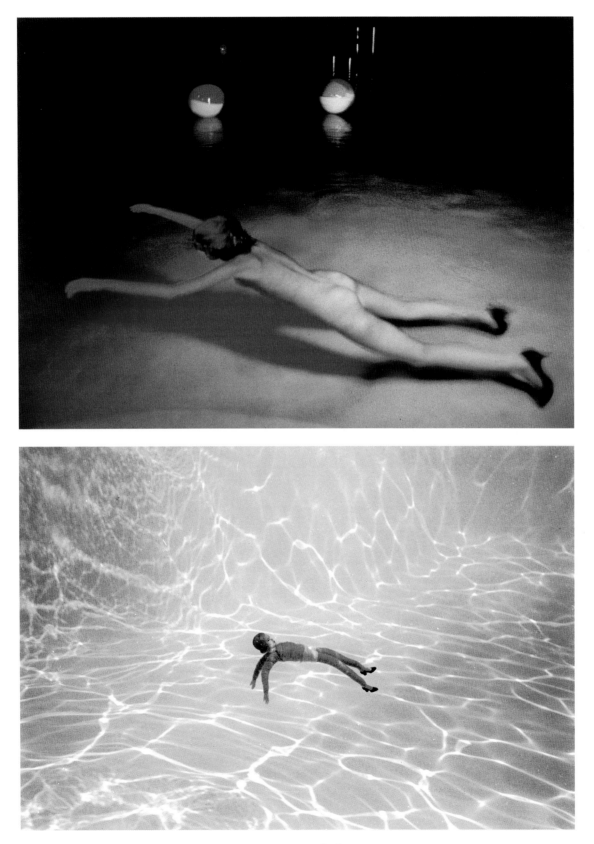

Upper: Jimmy DeSana. *Pool*. 1980. Cibachrome print. 20 x 24 in.
Lower: Laurie Simmons. *Woman / Heels (Floating on Back)*. 1981. 17 x 23⅝ in.

introduces titles that offer another layer of meaning to the work. *Calumny (The Shrug, The Hum, The Ha)*, *Calumny (Detail Truth)*, and *Calumny (Parade)*, signal the deception of

Film still from
Mr. Peabody and the Mermaid. 1948.

the water's lure (and of relationships as well). One swimmer moves in an opposite direction from the other in *Calumny (Detail Truth)* as if they are ships passing in the night. In *Calumny (The Shrug, The Hum, The Ha)* three figures appear to balance against each other, yet their actions seem unrelated. The images speak of the fragility of trust. The mercilessness of the sea and the bitterness of mistrust between individuals—as dramatized in such films as Alfred Hitchcock's *Lifeboat*, 1944, were vivid in Simmons's memory as she made this work.[14] She specifically recalled the enchanting mermaid, played by Ann Blyth, who eventually tries to drown her captor in an effort to keep him from returning to his wife in the movie *Mr. Peabody and the Mermaid*, 1948. A suffocating feeling pervades many of these sensual pictures, recalling the psychological contradictions of the "Interiors."

Directing and shooting "Water Ballet" was a noisy, complicated, and exhausting process, and very emotional for Simmons. A close friend had died shortly before she began this work. Being underwater had been comforting, but she needed to return to solitary work with the dollhouse figures. Working in black-and-white and color, she photographed an entire doll family underwater as surrogate parents and children diverged, collided, and overlapped in metaphors for relationships. The dolls' cloth-bound bodies (they are generally naked except for shoes) look bandaged and injured as they fall through the water. A son waves good-bye to a father who has drifted away. In *Ethereal Boy*, 1981, a tiny child floats in a vast nebula, suggesting his insignificance in the universe. Many of the figures appear to be drowning. *Woman/Heels (Floating on Back)*, 1981, portrays a nude female doll in high heels sinking in a swimming pool. The figure's pose is eerily similar to DeSana's staged crime scene photograph, *Pool*, 1980, for which Simmons was the model. (DeSana modeled for Simmons during the same shoot. Simmons and DeSana were steadfastly supportive of one another. He continued to be her technical guide and she was a frequent model for his photographs.) While Simmons was shooting the dolls underwater, the charged emotional and psychological issues of the work were not apparent to her. It was only after the film was developed that she saw the pictures' resonance and titled the series "Family Collision."

Following "Family Collision," Simmons again photographed real people. From January 1981 until September 1982, friends and acquaintances performed a simulated ballet in at least three productions. She leased a loft, rented and purchased costumes, hung curtains, put on music, and asked the untrained dancers to improvise, relying on their individual memories of ballet. After taking hundreds of unsatisfying pictures, she

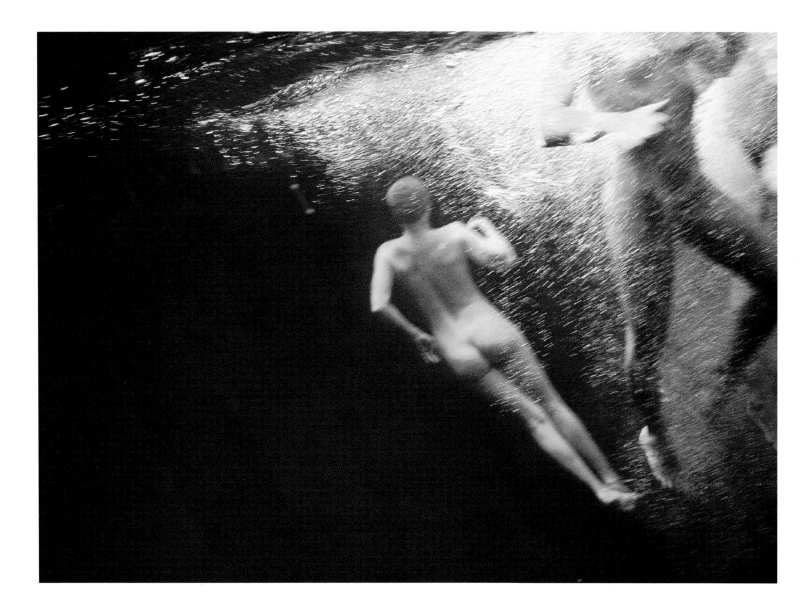

Walking Underwater. 1980. 17 x 23 in.

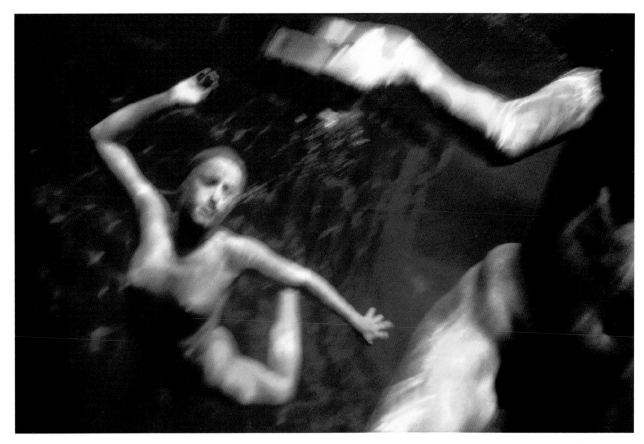

Bullet. 1980. 7¹⁵⁄₁₆ x 12⅞ in.

abandoned the project and returned to surrogates. In expensive ceramic figurines, cheap plastic cake decorations, and photographs in dance books and magazines, she found the clichéd ballet poses she had hoped to capture by using live models. Beginning with this group of pictures, the hunt for the right elements to combine in her pictures becomes a major part of the creation of the work. Photographic reproductions of the ballet were rephotographed in thirty-five-millimeter transparencies and projected as backdrops for the figures. Borrowing an illusionistic trick from the film industry, she placed the statues before a television-size, translucent rear-projection screen so that the figures appeared to be in the space of the projected scene.

Dramatically increasing the size of her prints to approximately thirty by forty inches—so large that she could no longer print her own work—these photographs compete in scale and presence with contemporary paintings. Their dark, soft-focus backdrops give the pictures the dreamy quality of the ballet. The figurines, approaching life-size, give the illusion of coming to life on the artist's simulated stage, fulfilling every little girl's wish, including Simmons's, of becoming a ballerina. Simmons loved the ballet lessons she took as a young girl and was bitterly disappointed when they were

replaced with piano lessons. As she was growing up, becoming a professional ballerina was a common (albeit terribly unrealistic) dream for a girl. At the time it must have

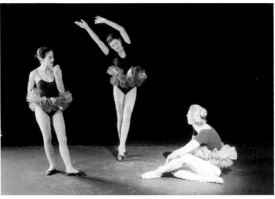

seemed the most desirable career among the few choices evident for women outside the home. Being a ballerina was certainly more glamourous and romantic than being a teacher or a nurse or a secretary, and it was a more dignified and elevated profession than that of an actress or singer. The ballerina was the epitome of femininity as cowboys were the epitome of masculinity. The ballerina's body, costume, and movement give her an ethereal appearance that belies her extraordinary

Untitled, from "Fake Ballet." 1982. (Never printed).

strength and stamina. Many girls of Simmons's generation were sent to ballet school to learn to move with grace and poise as part of their training to be desirable. Simmons's use of surrogates in cliché poses underscores her critical view of the ballerina's popular image. The ballerina was often not recognized for her achievements gained through hard work and discipline; like the ballet figurine, she was seen as a fragile object of beauty.

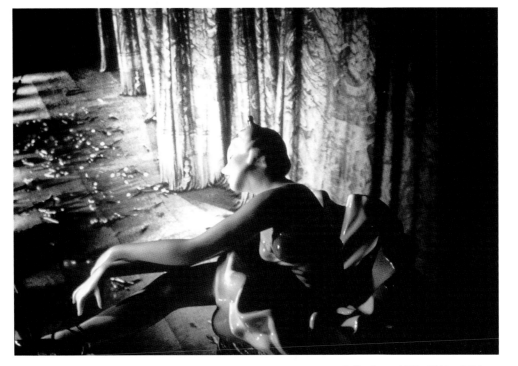

Ballet Stage. 1983. 28⅛ x 35½ in.

. . . I came across these very strange and sci-fi looking dolls. They're called the "Teenettes" and they were a Japanese toy maker's idea about the American woman. They're kind of distorted, as you might expect, but the fact that they were colored monochromatically was a terrific metaphor for me. . . . I simply worked in a very formulaic way to find rooms that were decorated in the style that was prevalent in the sixties and seventies where a room would have a theme color. So the green doll would be placed in a green room, the red doll in a red room, the yellow doll in a yellow room, and the blue doll in a blue room, and that for me said something about women actually becoming or fading into their environment.[15]

Simmons's reexploration of women's invisibility, begun in the "Interiors," was triggered by finding the Japanese monochrome figurines. The Japanese version of an American teenager was outfitted in conservative attire, so the dolls easily pass for 1960s housewives when posed before Simmons's rear-screen projections of color-matched rooms. The formulaic method of constructing this series can be seen as a further exploration of the systemic process she first explored in the "Black Series." The artist rephotographed the room backdrops from interior decorating books of the 1960s and 1970s and from images found in the New York Public Library's Picture Collection. Though rear projection placed the dolls illusionistically in the pictured rooms, Simmons heightened the artificial quality of the scene by using uneven lighting (the three-inch figures were lit with flashlights), shallow depth of field so that the dolls but not the background are in focus, and inconsistent scale. Each artistic device provided evidence of the pictures' fictive construction.

From the mundane kitchens of middle-class suburbia to the luxurious bathrooms of the wealthy, Simmons matched surrogate homemakers to the decor of their interiors. In *Yellow Bathroom*, 1983, the figure glows with the radiance of the golden bathroom. These elongated dolls, like the stereotype of their human counterparts, never become more than objects. The invisibility of the character recalls Delia Grinstead in Anne Tyler's novel *Ladder of Years*, 1995, who is so completely taken for granted by her family that when she leaves them, they cannot even describe her most basic features for the missing person's report.

The "Color-Coordinated Interiors" also parody conformity to current fashion and interior design. Cookie-cutter figures, available in four colors and five poses, are pictured in the cookie-cutter environments of trend-setting journals. When more than one of the same type doll appears in a picture, we hardly notice, so accustomed are we to seeing people who dress alike and adopt the same hairstyle. Like the plastic figures,

women packaged by the media for commercial purposes often appear to be cut from the same mold. The dolls' mass-produced shiny plastic bodies and claw-like hands have caused many critics to read them as the robotic *Stepford Wives*. Yet if the "Teenettes" are indeed read as teens, the issue of conformity is even more crucial. As adolescents strive for acceptance by their peers they are ever more conscious of the need to fit in. Simmons, in fact, often thought about her relationship with her two sisters as she posed the dolls in these images. In a purposefully emotionally cool tone, she touches on the social dynamics of girls in various groupings.

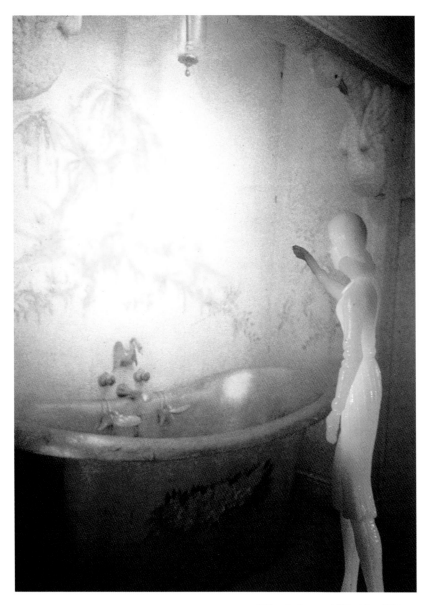

Yellow Bathroom. 1983. 40 x 29¼ in.

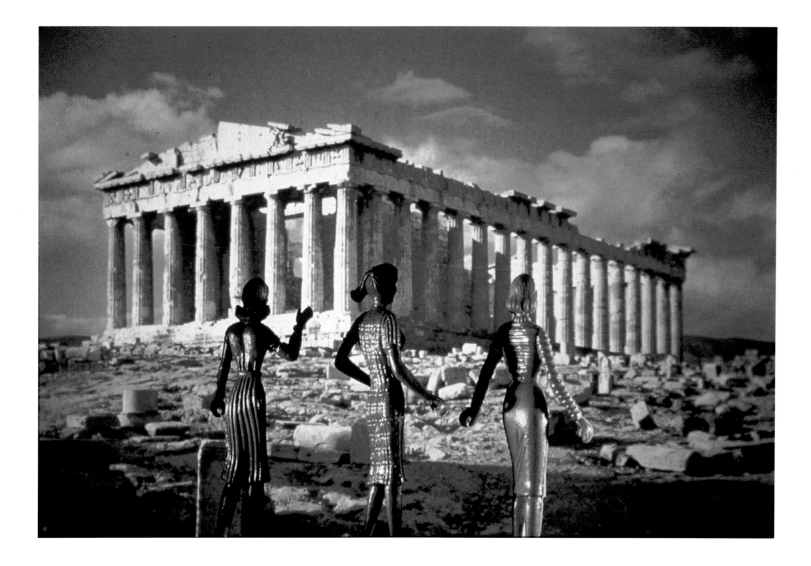

Tourism: Parthenon. 1984. 40 x 60 in.

I was in Greece in 1983. I was standing on the Acropolis, in front of the Parthenon. I was with a couple of friends, and it was really hot and crowded and polluted. . . . I had a camera, but it was not something that I really felt like using. . . . It was an unpleasant experience, and I said to my friends, "You know, you get a better sense of this place in books. You can see it better in pictures." The people I was with were irritated by what I had said, and they were teasing me about it. I started thinking about how experience has been mediated for us through textbooks and tourist guides. The images have been shown to us over and over again, so many times that by the time you come to the real thing—what a letdown. It's so much more beautiful in a travelogue.[16]

Just as typical representations of women's roles were inconsistent with Simmons's experience, so too were reproductions of the Parthenon inconsistent with her real-life experience. As if to make us aware of the contrivance of pictures we routinely accept as factual, Simmons created an obviously fabricated travelogue with the "Teenettes" touring the world via rear projection. Traveling in groups, the doll-toys are pictured in souvenir photographs standing before such wonders of the world as the Eiffel Tower, the Taj Mahal, the Great Wall of China, and the Pyramids—all sites well known to us through photographic reproductions. Simmons's pursuit of this subject may have been a response to the theories with which her work was being associated at the time. This body of work in particular fits neatly into postmodernist criticism about the impossibility of original experience: since we approach everything, the theory goes, with a preconception provided by the media, we cannot experience anything without a memory of it already present.[17]

Before Simmons began shooting this series she compulsively gathered hundreds of slides of monuments, beginning with a set of Greek archaeological sites from a tourist shop near the Parthenon and from the slide library of The Metropolitan Museum of Art in New York. As she gathered the slides, the predominantly phallic shape of the monuments became apparent to her, and it struck her that these monuments were built by and for men. Her women are liberated from the confinement of the home to travel the world and experience these male achievements.

She used the same strategy to shoot the "Tourism" series as she used for the "Color-Coordinated Interiors," populating unrealistically pristine postcard views with her dolls via rear projection. The figures are color-cued to the background scene, which was often unintentionally monochromatic owing to the poor quality of the slide. The Parthenon and Antonio Gaudi's towers are blue, Stonehenge is pink. Increasing the size

of her prints still further, these sixty-by-forty-inch Cibachromes are face-mounted to Plexiglas and were originally presented flush to the wall, without frames. Their vivid color and enormous size were inspired by the exaggerated version of reality portrayed in wide-screen CinemaScope films. Creating picture windows onto the world, Simmons calls attention to the powerful presence in our mind's eye of secondhand views.

Even as "Tourism" employs commercially produced views, Simmons's pictures are modeled on amateur souvenir snapshots. As she posed the "Teenette" tourists she was imitating her father's vacation photographs where he carefully centered her family in the scene. The tourists who pose before famous sites—proving they were there—are the point of many travel snapshots. But Simmons's dolls do not pose for the camera; they are simply caught in the frame. These are the tourists who get in the way of the photographer attempting to capture an unblemished view of the site. The pictures could represent souvenirs of anyone's trip. We have to look through the figures to view the important monument in the photograph, as the surrogates blend into each site. For Simmons these pictures are "about how difficult it is to be singular, how few situations there are that are particular. And there's also the issue of desire and longing, of wishing to be somewhere, wishing to be able to do something well, of wishing to be someone

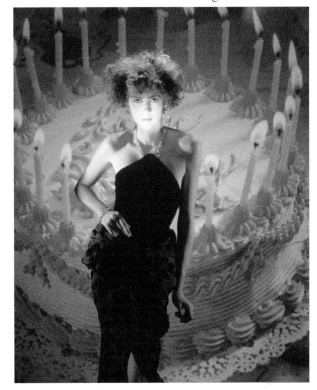

For Diane Von Furstenberg. 1984. 10 x 8 in.

significant."[18] It is often when we are traveling or otherwise away from our daily routine that we see other possibilities for our life.

Sometimes we fulfill longings about who we want to be by the way we dress. In 1983 Simmons began shooting fashion photographs for clothing designer Elizabeth Cannon, using backdrops gathered during her "Tourism" research. In 1984 she was commissioned to do a fashion spread for the Brooklyn Academy of Music's "Next Wave Festival" catalogue for its 1985–1986 season. Simmons had always loved radical fashion photography, she had studied fashion illustration as a teenager, and she had fantasized about shooting fashion, so she relished these opportunities to play with its conventions. For the BAM project her studio was transformed from a private space to one buzzing with professional models, hair stylists, and makeup artists. The tousle-haired model in *For Diane Von Furstenberg*, 1984, stands before

a projected birthday cake larger than she is, as if she has just popped out of it. Her black evening gown, a familiar Barbie doll costume, parodies the model's often artificial doll-like appearance. The model's fingers are even frozen in the strange gestures often found on these dolls. The image suggests the stereotype of women, especially models, as "cheesecake." In *For Calvin Klein*, 1984, the model seems involved in some kind of intrigue. She poses with a stock expression of suspicion and ambiguous shadows are cast behind her. In a jacket and bare legs she holds up a pair of pants as if choosing this outfit were some kind of crime. Simmons is attentive to the sex, glamour, and excitement advertisers work overtime to associ-

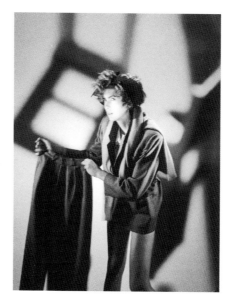

For Calvin Klein.
1984. 10 x 8 in.

ate with their products in order to fire the consumer's desire to live these fantasies by buying their products.

After working for hire as a fashion photographer, Simmons continued to explore the genre in 1984 in a series called "Fake Fashion"—a follow-up to the faux ballet pictures she had attempted a few years earlier. The photographs were set up just like her real-life fashion photographs, but they fall flat since the artist purposefully eliminated all sense of style. She dressed professional models in the cheapest polyester clothing— apparel that had the appearance of plastic—with the goal of creating a living doll. Sometimes the model was posed against slides of outdoor settings, sometimes against interiors Simmons had designed with dollhouse furniture and photographed specifically for this purpose. "I had made pictures of fake people in real places, and I wanted to picture real people in fake places." Again

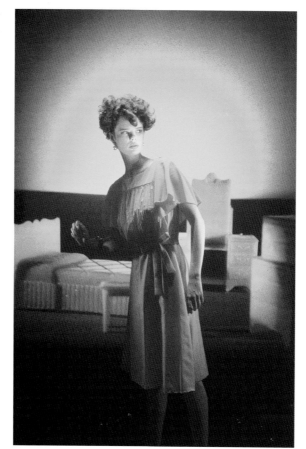

Orange Bedroom. 1984.
60 x 42½ in.

she was using dislocations in the picture to parallel irreconcilable parts of our lives.

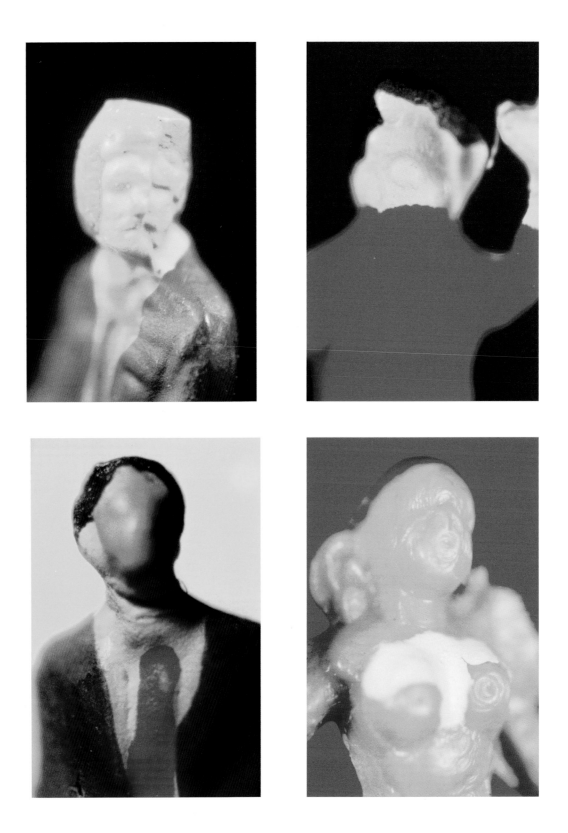

"Actual Photos." Collaboration with Allan McCollum. 1985. Each 9¼ x 6¼ in.

. . . I remembered all those comic books in the 1950s where you could send away for, say, monkeys that fit in teacups, and underneath the picture it would say "actual photo" or "actual size" so you'd know that you'd receive a three-inch monkey, and that the image wasn't a life-like drawing. I think of scientific veracity as an idea from the past—the scientists say this is so, the photo is proof. Even the authoritative power of the word "actual"—an actual what? . . . People are much more willing nowadays to believe that pictures lie than that they can express any kind of truth.[19]

"Actual Photos," a 1985 collaboration with Allan McCollum, undermined scientific methods in a perverse investigation of stereotypes. McCollum, a friend with whom Simmons often discusses her work, suggested that since she was interested in making pictures that intentionally failed to work as documentation, such as "Fake Fashion," she should try photographing figurines so small their features could not be read. Simmons thought the idea sounded more like his work than hers. McCollum had begun a series of "Perpetual Photos" in 1982 in which he rephotographed scenes from television and the newspaper that included pictures hanging on the wall of interiors. He isolated a picture from the interior setting, greatly enlarged it, and then framed it so that in its new presentation it was impossible to discern what it might originally have represented. The surrogate photographs followed a series of "Surrogate Paintings," wood and molded fiberboard objects in the shape of framed pictures painted in monochrome. In 1985 McCollum also began to make surrogate drawings and sculptures. He consistently emphasized the role of these works as objects in the art world, in the home, and in a class-differentiated society. Since Simmons had been investigating society's prescribed roles for women and men through surrogate figures, the two artists decided to pursue McCollum's idea together.[20]

Figures from HO- and Z-scale model-train sets provided their subjects. Hundreds of occupations and roles were portrayed—children, doctors, housewives, construction workers, and lovers, to name a few. They were cast in plastic, most about one-quarter-inch high with heads less than one-sixteenth inch in diameter. Though they were hand-painted with a single-hair brush, their features were indistinguishable to the naked eye. McCollum and Simmons hired a medical technician in a pathology lab to photograph under an optical microscope every figure they purchased. Each was shot against a solid red, yellow, blue, green, and black background. (The collaboration was the first instance in which Simmons removed figures from a contextualized setting, an approach she eventually would use again.) Once the artists had transparencies, they selected the best background color for each figure. The thirty-five-millimeter slides were enlarged

to approximately 9¼-by-6¼-inch Cibachrome prints, with fifty-one images in the set. (Although the series was intended to be open-ended, no other pictures have been added thus far.)

The mass-production approach to creating "Actual Photos" mimics the production of their subjects. Yet the magnified heads, blob-like and fuzzy, are surprisingly resonant. It is impossible to know what character each portrait represents but it is also impossible *not* to see a familiar character in most of these heads. Even as these pictures subvert their original stereotypes, other types are unavoidably read into them. The viewer projects personalities on each head even though some heads are so deformed they would not be recognized as figures outside the context of the series.

The random distortion of the faces that occurs during their manufacture and the intensity of color with which they are painted project an unintended expressiveness. Saturated color grounds vibrate against the equally vivid swaths of color on the figures. They evoke the style and figuration of twentieth-century expressionistic painting and prefigure the sagging faces of Thomas Schütte's figures in "United Enemies," a series he began in 1992. It is as if in stripping away the stereotypical identity of each figure, an inner voice was revealed. Yet the solid-colored backgrounds framing each face also hint at the neutral backdrops of identification photographs. These pictures, however, mock the idea of a photograph as proof of identity—or of anything else. This microscopic scrutiny deceives even as it appears to reveal. A powerful magnifying lens was a surprisingly effective tool for breathing the illusion of life into minute toy surrogates.

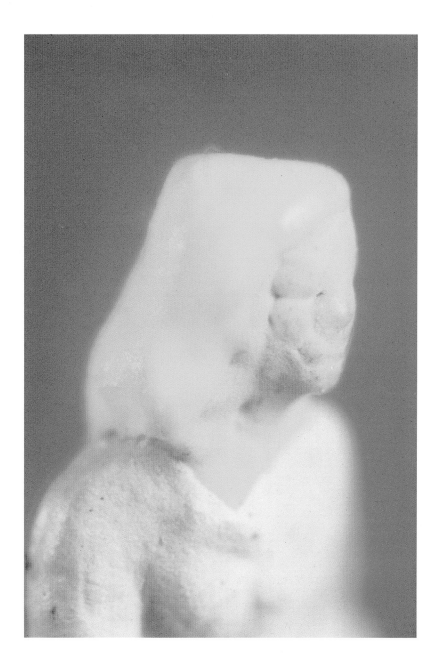

"Actual Photo." Collaboration with Allan McCollum. 1985. 9¼ x 6¼ in.

Single image from *Boy Vent Press Shots (Hats)*. 1990. 10 x 8 in.

VENTRILOQUISM

"Uh, . . . Danny?"

"Yes, Nelson?"

"It seems to me that, if I could teach you how to be a ventriloquist, I could teach just about anybody."

"That's a heck of a way to start this record, Nelson. Why, isn't this supposed to be a simplified ventriloquism for the beginners?"

"Right."

"I'm way past that stage, I haven't been a beginner for years!"

"I know that, Danny, but you've been a dummy all your life, and I"

"Gee, watch your language, Nelson!"

"Sorry. . . . Alright, Danny. The first thing to learn is that ventriloquism is basically the art of being able to talk without moving your lips. Now, the word 'ventriloquism'—or 'ventriloquy,' as it's sometimes called—comes from the Latin 'venter.'"

"What does that mean?"

"It means 'the belly.' And 'loqui'. . . ."

"What does that mean?"

"To speak."

"Venter—the belly."

"Uh-huh."

"Loqui—to speak."

"Right."

"I get it. You're a belly-speaker. Is that anything like an after-dinner speaker?"[21]

This dialogue between ventriloquist Jimmy Nelson and his figure Danny O'Day is not one remembered from Simmons's childhood, although she did spend a lot of time with her friends practicing ventriloquism with a Jerry Mahoney dummy as she was growing up. She was awed by ventriloquism as a child. Jimmy Nelson and Paul Winchell (the voice of Mahoney) were the stars of early television's ventriloquism revival. When Simmons was looking for a doll-like male figure to use in her photographs, the ventriloquist's figure occurred to her as "fertile territory in terms of taking pictures. So many kinds of male relationships came up between vent and dummy: paternal, buddy love, best-friend love, brotherly love, homosexual love."[22] She contacted the vent Doug Skinner, who she knew had an interest in art, and began to photograph him and his figure Eddie Gray against rear projections. ("Vents," as ventriloquists call themselves, usually refer to their wooden partners with the more respectful term "figure," not dummy.)

In one of her first pictures combining a real person and a surrogate, Simmons delved into a seemingly off-stage relationship between the ventriloquist and figure, giving the

illusion that she was photographing them at home by using domestic backdrops. Photographed shortly after the birth of her first daughter, she pictured them as father

Untitled (from *Ventriloquism*). 1986. Photolithograph. 33½ x 26⁹⁄₁₆ in.

and son. The first ventriloquist images she exhibited were three prints from the portfolio *Ventriloquism*, 1986, published by Ilene Kurtz in New York. Two photogravures depict Skinner and Gray against backgrounds taken from a trick photography book, playing ventriloquial illusions against photographic illusions. The photolithograph from the portfolio is an eerie close-up portrait of the dummy alone. With this image she hit on her new subject. The smirk on the dummy's face and the unnerving way he leers at the viewer bring it to life. Simmons does not need a ventriloquist in the picture; it is the role she has played all along—giving her surrogates a "voice" but keeping control of the dialogue. Just as confronting this dummy makes us squirm, viewing her earlier pictures also typically generates some degree of discomfort, both pictorially in the dislocations of subject matter and psychologically in the dislocations of meaning. The dummy is the ideal vehicle with which to increase the level of discomfort in the pictures while still play-acting. The demoniacal portrayal of dummies in *Twilight Zone*-type episodes and films gives these surrogates a more deviant set of associations than those of any of her previous figures.

To photograph a series of dummies, Simmons traveled to the homespun Vent Haven Museum in Fort Mitchell, Kentucky. Dedicated to the art of ventriloquism, its collection comprises 540 figures, some as early as the Civil War period. Simmons was, predictably, most attracted to the figures from the era of her childhood. She made four trips to Vent Haven to research and photograph dummies. At the museum she set up a makeshift portrait studio where she had sittings with ten to twenty characters each trip. She did not have an agenda in choosing which dummies to photograph. She knew only their names and sometimes the date they were made. "It was totally intuitive, who looked appealing, as if I were making a friend." She posed them on the museum's child-size folding chairs before rear-projected slides of solid-colored or fake interior or outdoor scenes, resembling the kind of backdrops typically found in portrait photography studios handed down from centuries-old traditions in portrait painting. Eager to follow

those conventions, Simmons consulted the staff at the National Portrait Gallery to learn the most common formats, arriving at a half-length view, usually showing both hands, typically thirty-five by twenty-five inches.

Pancho, 1988, is an aging, glassy-eyed Don Juan dressed in a broad-striped jacket and red vest. He is posed as if he were caught off-guard—a device to bring him to life since he cannot "speak" in her pictures. Slouched in his chair, he stares reflectively at the ceiling. A red backdrop accentuates his flamboyant appearance, seeming to situate him in a nightclub rather than a studio. He is, curiously, both repulsive and captivating. *Jane*, 1988, seems to be caught off-guard too. Her head is turned sharply to the right as if she had just been distracted. Her dress and facial features could be those of a girl or a woman. She conveys an awkward schoolgirlish charm as she looks coyly to her side. Seated against the foliage-patterned wallpaper, she might be a wallflower, but then again she seems to have something up her sleeve. Simmons exploited the unique characteristics of these new surrogates: in our imaginations dummies lie somewhere between a living creature and an inanimate object—we do not trust that they are either. Ventriloquism begs questions of trust: we are thrown off balance about who is talking and where the truth lies. These can be the same uncertainties we feel about memories—and, of course, about photographs. With the ventriloquial figure as subject, Simmons's passion for creating illusion and querying deception is sustained.

What is so compelling about many of Simmons's pictures, from the "Interiors" forward, is how she acts as ventriloquist not only by giving her figures a voice but also by emotionally connecting the viewer to her figures. The gifted ventriloquist not only excels at talking without moving his or her lips, but also conveys the illusion that the dummy is real and has an often fractiously independent personality. Once an audience is convinced of a ventriloquist's lip control, its attention is riveted by the figure, while the ventriloquist becomes the "straight man," a medium, oddly invisible. The dummy, on the other hand, is animated and funny, delivering all the punch lines. The dummies of Simmons's childhood were typically spiteful. She remembers the acts as "Wisecracking, male bonding sessions with slightly off-color jokes, all at girls' expense."[23] The fundamental conceit of ventriloquism rests on the illusion that the dummy is a small person, often with a rebellious attitude that is not quite adult. The audience accepts that the ventriloquist is not responsible for what the dummy says, and the dummy's socially unacceptable and even sadistic remarks are permitted. Taboo subjects and vicious thoughts are socially legitimized—indeed, hilarious—when spoken through the dummy.

The dummies at Vent Haven were not the only source of inspiration for Simmons. Publicity photographs of the vents and their figures cover the walls of the museum, revealing the range of figure types and relationships between the vent and partner. Simmons photographed a selection of press photographs, creating three works titled *Boy*

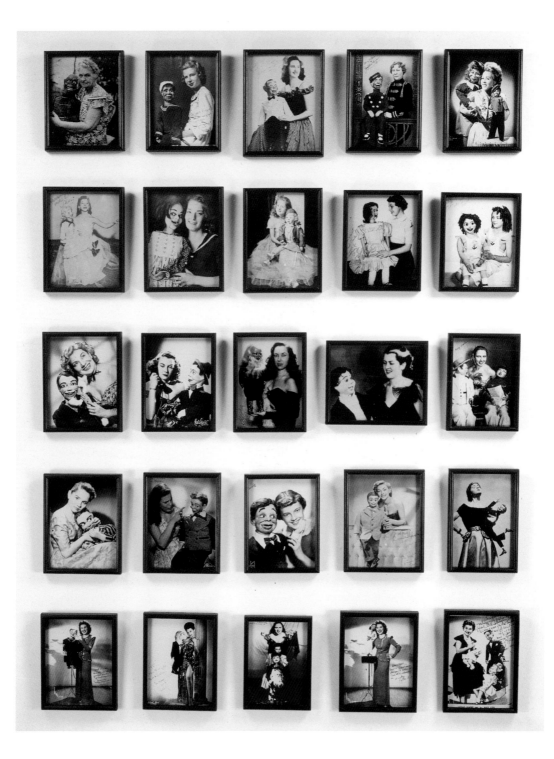

Girl Vent Press Shots. 1988. Twenty-five approx. 10 x 8 in. and one [page 53] 68 x 48 in.

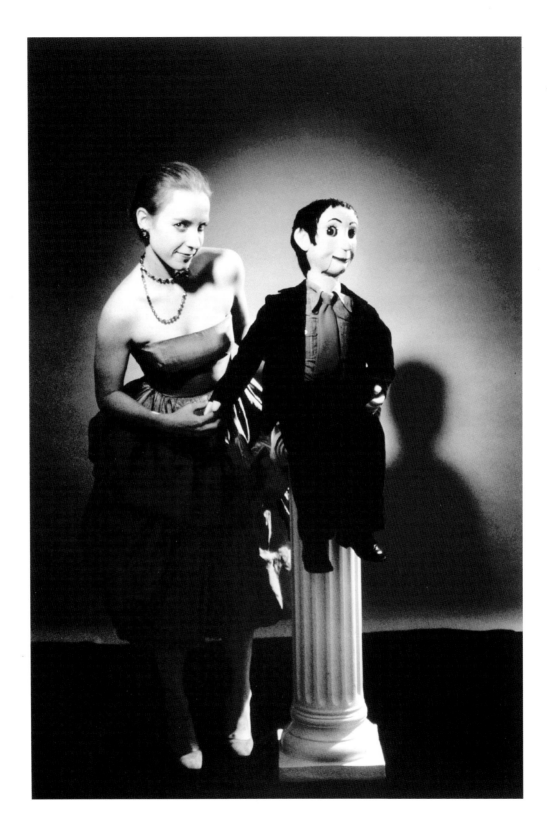

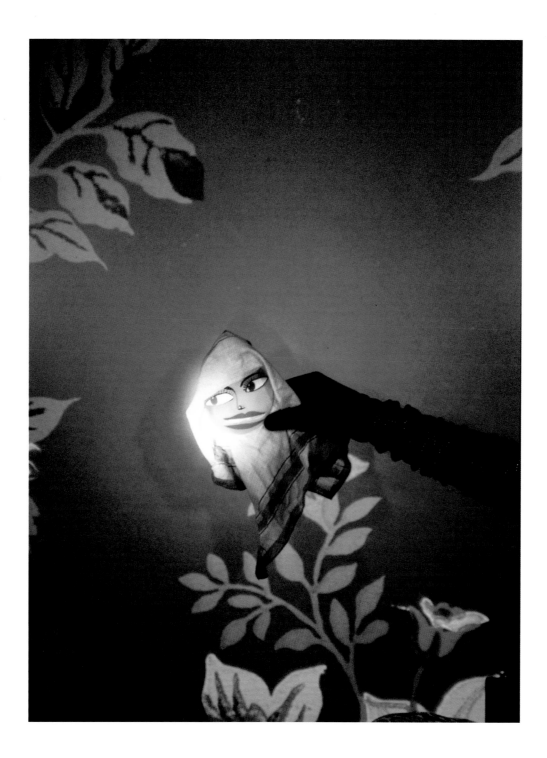

Talking Handkerchief. 1987. 63¼ x 44½ in.

Vent Press Shots, 1988 (one focused on children and animal figures, one on figures and vents in hats, and one on figures and vents in tuxedos), and one *Girl Vent Press Shots*, 1988 (there are relatively few female vents). Each set consists of twenty-five press shots—five rows of five related pictures. *Girl Vent Press Shots* includes an additional large photograph that Simmons fabricated in the style of the press shots. The press shots of the female vents are particularly revealing in the relationships between the vents and their figures. The frequent portrayal of female vents with boy figures in their laps reminded Simmons of conventional representations of the Madonna and Child. One senses the protective and controlling relationship of mother to child in many of these images; some are almost illustrations of the kinds of control one person can have over another. The images with young girl vents suggest sibling rivalry. Many of the women vents clearly play on sexual tension with the male figure, but in ventriloquism, when their partners are dummies, females dominate. As a group these images seem to present the many voices that exert control over the development of a self.

The photograph that Simmons staged to accompany this set focuses on this relationship between vent and figure. Its large size (it is larger than the full grid of rephotographed press shots) makes us question whether all the photographs are staged or appropriated. The deception in the artist's working methods parallels that of ventriloquism. Recreating a press shot provided the opportunity for Simmons to picture her fantasy about the relationship between vent and dummy, as she had in the first pictures of Doug Skinner and Eddie Gray. Skinner again assisted with this image; his girlfriend is paired with another of his boy figures. The picture is modeled on the full-length glamour portraits of female vents with male dummies included in the *Girl Vent Press Shots* and captures the uneasiness of those images. The actor vent, playing Simmons's role, leans over the dummy, looking out toward the viewer with an expression of superiority. She holds him upright on a pedestal, yet she is still taller than he is. A memory from Simmons's early years in New York City of a visit with her neighbor, a dwarf, likely played into her thinking about this picture. "He invited me up for a drink and introduced me to his very beautiful, normal-size wife. He poured me a glass of wine and we all sat down. She picked him up and put him on her lap like a little child. I found that very sexy. I never forgot the image. The scene made me feel a bit uncomfortable, but it stayed with me that she had that kind of control over him, and that she was unashamed to be seen in this position—a little boy-man on her lap."[24] As her work developed, Simmons more frequently posed her surrogate women in positions of power.

At Vent Haven Simmons also photographed the "talking" props vents use in addition to figures, such as gloves, walking sticks, purses, handkerchiefs, and many other everyday objects that have been given a voice. In this series, performances were staged for the camera against rear-projected backdrops of Depression-era domestic wallpaper.

Talking Handkerchief, 1987, a veiled lady with bright red lips and large almond-shaped eyes, is one of the most suggestive actors in the group, coyly posing for attention. The talking objects are a nostalgic visualization of childhood dreams where one's possessions come to life. Adding these animated objects to her repertoire, Simmons opened her dialogue to a degree of fantasy and playfulness that is in sharp contrast with the dummy portraits. The anthropomorphism of "Ventriloquism" was taken up with greater authority in the "Walking Objects" series begun in 1987 with *Walking Camera I (Jimmy the Camera)*.

WALKING AND LYING OBJECTS

I had seen when I was a child a TV show in the fifties where there were dancing cigarette boxes and dancing matchboxes and it always stayed with me as a kind of image of something that was so physical, without a brain, without a heart, without a mind—but maybe something just about joyousness and gleefulness and fun. Those ideas spawned the image of the camera on legs and from there it just seemed like there were a number of creatures I could make.[25]

The first "Walking Objects" were conceived as figures dancing across a stage, much like those of the Old Gold television commercial that inspired them. *Walking Camera I (Jimmy the Camera)* portrays a massive box camera (a prop from the 1978 film, *The Wiz*, borrowed from the American Museum of the Moving Image in New York) in dance tights and ballet shoes. The other images from this shoot reveal that the model was actually dancing in the studio. The model for *Walking Purse*, 1988, wearing dance tights, tap shoes, and a giant purse that Simmons had manufactured for her, also pranced around the studio for the second photograph in the series.

Jimmy the Camera is an enormous creature, seven by four feet, in control, standing on its own two feet. It can be read as a metaphor for the camera's omnipresence in today's world; nothing seems to be out of its range. Jimmy DeSana was an appropriate model for the picture. The sexual fantasies he devised for the camera pushed the boundaries of subject matter in art. The photograph is a tribute to DeSana. Simmons knew he was dying and she made the picture as a way to hold onto him. *Jimmy the Camera* attests to their long working relationship but it is also about Simmons. DeSana taught her how to use the camera and how to process her work, and by the late eighties Simmons was receiving recognition for her photographs. They were widely collected and she was supporting herself for the first time through their sale. The picture is almost certainly also a celebration of Simmons's own feelings of earned power and control.

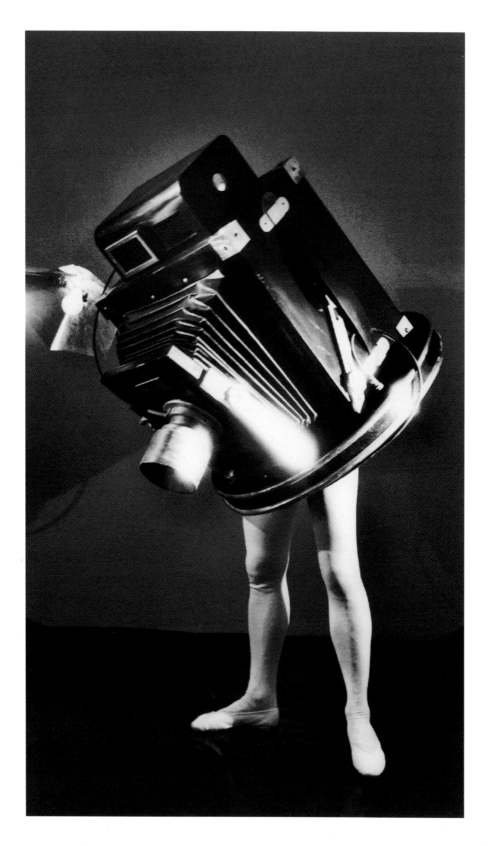

Walking Camera I (Jimmy the Camera). 1987. 83¼ x 47¼ in.

For *Walking Cake*, 1988, Simmons commissioned a cake nearly four feet in diameter, but when she realized it was going to cost thousands of dollars to ice it, she knew it was time to return to miniatures. She had always been attracted to photography for its ambiguity of scale and the illusions she could create, so she ordered a synthetic cake from a pastry maker and affixed similarly scaled artificial legs to it. The image is a conflation of the model and birthday cake pictured in Simmons's fashion shot for the Brooklyn Academy of Music. (The cake was designed after the one in the BAM picture.) *Walking Cake* is a birthday present—a beautiful, sweet, delectable morsel presented for the enjoyment of others.

For the remainder of the series Simmons matched miniature and life-size objects to appropriately-sized doll or mannequin legs, usually recognizable as a woman's. As she animates the objects, Simmons plays out various roles. Her transformed women parade across a simulated stage as if in a fashion show or a musical, wearing the accoutrements with which they are identified. You can almost hear a catwalk narrator for *Walking Purse*:

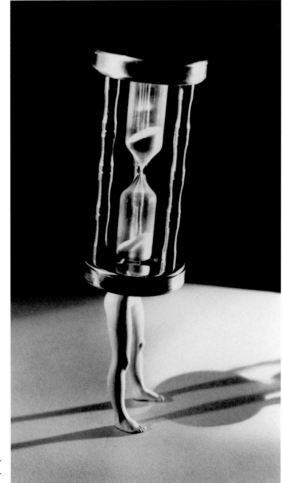

Walking Hourglass.
1989.
84 x 48 in.

"Woman as the perfect accessory to be worn on the arm of the successful man." Or, more practically, this time the woman holds the purse strings. With her enormous vintage alligator bag, she is the stereotypical ultimate shopper. The references are sometimes many and layered. *Walking House*, 1989, reaches back to Simmons's earliest pictures of the woman whose identity is inseparable from her role in the home. It is likely a reference to Louise Bourgeois's 1947 drawing of the same subject, *Femme/Maison—To Carletto*, which appeared on the cover of Lucy Lippard's seminal 1976 book *From the Center: Feminist Essays on Women's Art*.[26] *Walking Hourglass*, 1989, conjures up the destructive pressures in our society to attain the starlet's perfect body, and at the same time reminds us how fleeting physical beauty and life really are. Almost a memento mori, it recalls the soap opera refrain, "Like sands through the hourglass, so are the days of our lives." *Walking Gun*, 1991, is a vivid metaphor for the fear everyone lives with today—women in particular— ever ready to protect or defend ourselves. She is also the mythic femme fatale with the gun handle

acting as the short shirt revealing the alluring legs of her treacherous being. As Simmons developed the series, she was amazed to reflect on how easily women were subsumed by any object. It reinforced for her how difficult it is for women to be recognized as individuals distinct from their stereotypical roles.

The "Walking and Lying Objects" have precedents in works by the Surrealists who relished the dislocations produced by the unlikely combinations of objects, usually at the expense of women. Man Ray's *Le Violon d'Ingres*, 1924, is a stunning and well-known image demonstrating the objectification of a woman. Man Ray saw in the back of his

muse, Kiki de Montparnasse, both an Ingres bather and the shape of a violin (the instrument of Ingres's hobby), and he superimposed on her body in this famous photograph drawn sound holes, thus transforming her into a violin. Kurt Seligmann used female mannequin legs for the legs of a stool in *Ultra Meuble*, 1938, contracting a woman into a lap.[27] Simmons's *Bending Globe*, 1991, a view of a female figure's posterior as she bends over with the weight of the world, is a direct reference to the historically male portrayal of woman as sex object in fine art and popular culture. The legs for this figure are from a Japanese modeling kit called the "B Series." "They're like bondage dolls. They come in pieces with little chains. Like ship models, they're very elaborate. You put them together, you sand them, and you paint them." Her image is built on entertainment conventions (the can-can dancer or Las Vegas showgirl provocatively shaking her fanny in the face of the ogling male), but it is a tough picture of women's universal challenge.

Man Ray. *Le Violon d'Ingres*. (1924). Gelatin silver print. 7½ x 5¹⁵⁄₁₆ in.

For the series' grand finale, Simmons created *Magnum Opus (The Bye-Bye)*, 1991, with six figures taking the stage in a final number: a new camera (now sitting), a toilet, a new house, an hourglass, a sitting microscope, and a clock. The title is double-edged. Her self-anointed "Major Work," a work seven by twenty feet, is a wry comment on the pantheon of "master" works by male artists. Its parenthetical title, "The Bye-Bye," is cute baby talk harking back to the stereotypical dumb-blonde showgirl. They represent the two worlds, high and low culture, that Simmons conflates in nearly all of her work. The bold presentation of these outrageous, poignant figures ranks these pictures among Simmons's most powerful works.

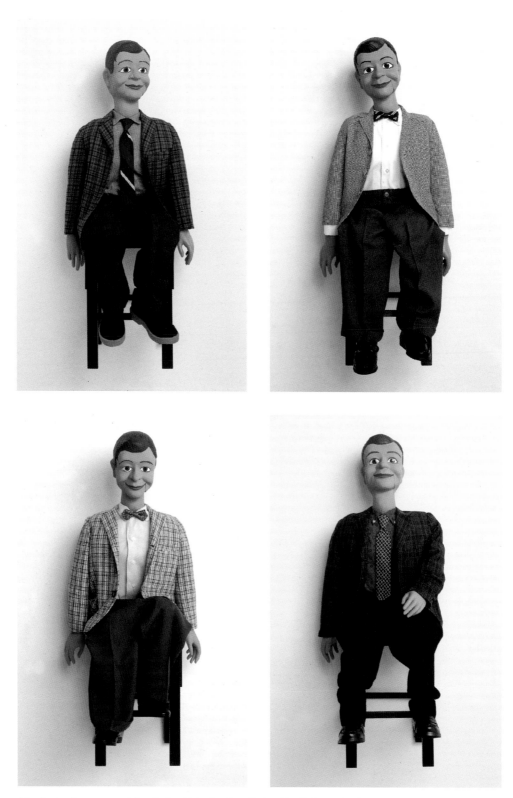

Clockwise from upper left: *Clothes Make the Man (don't ask)*; *Clothes Make the Man (tell me about it)*; *Clothes Make the Man (you betcha)*; *Clothes Make the Man (ask any woman)*. Each 1992, mixed media, 39½ x 12 x 15 in.

CLOTHES MAKE THE MAN AND
CAFE OF THE INNER MIND

Do you remember the movie The Man in the Gray Flannel Suit? *There were real issues of conformity when I was growing up: how important it was to be like other people, how important it was for our parents to conform to a certain social group and have their children conform to a certain mode of behavior.*[28]

Returning to a male focus, Simmons examined how the subtle variations in men's clothing reveal personality in "Clothes Make the Man." In what was for her a radical move, she commissioned the fabrication of identical dummies to model clothing, but not for photographs. She conceived of them as sculpture. She worked for a year with vent and figure maker Alan Semok to design a male face. "He was a compilation of my recollection of what a dummy is supposed to look like. It was this smart-alecky 1950s–1960s look, and although I've never seen a dummy that looks exactly like the one I made, it sure looks like what I remember." Although it is made with new materials—its face, hands, and feet are molded fiberglass—it was important for Simmons to find someone who was still making figures in the style of those she had seen growing up. Her first figure was made with a movable mouth so it could be used in performance, a project Simmons has considered for video. Seven clones were made (without the movable mouth) with the idea that more figures could be made as needed.

"Clothes Make the Man" was first exhibited at Metro Pictures in 1991 in an installation of three figures sitting in chairs mounted one to a wall, each wearing a different outfit. Each figure has a subtitle—a hackneyed expression to fit its personality-defining attire. In *Clothes Make the Man (and I should know)*, 1990–1991, the dummy is dressed in a tuxedo and exudes wealth. *Clothes Make the Man (you better believe it)*, 1990–1991, portrays a flamboyant character wearing printed pajamas, slippers, and a flannel robe with rope-braid trim. Simmons does not miss a detail, down to the shoes they wear. In *Clothes Make the Man (don't I know it)*, 1990–1991, the dummy is a preppy snob in bow tie and khakis. The characters in a second group made in 1992 are all dressed in a casual jacket and tie, but the subtle differences in each outfit send clear signals about their identities: There is the sporty guy dressed in canvas shoes in *Clothes Make the Man (don't ask)*; the intellectual in bow tie *(tell me about it)*; the traditionalist in double-breasted brown tweed *(always did, always will)*; the eager young professional in the dark shirt and dark tie *(you betcha)*; and the cad in bow tie and plaid blazer *(ask any woman)*. You don't have to hear these dummies talk to peg their personalities.

In addition to the external codes of male identity evoked in "Clothes Make the Man," the series addresses the psychological aspects of the artist's interaction with dummies—not-quite-real "little men." The physicality of the dummies, as opposed to their

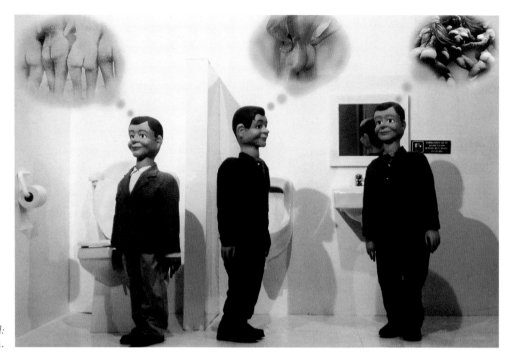

Café of the Inner Mind:
Men's Room. 1994. 35 x 53 in.

representation in a photograph, makes one more conscious of Simmons's relationship to them. She has said that one reason for making them was because she missed the tactile qualities of working with dummies after she stopped making trips to Vent Haven. The figures are not just objects to her; she treats them more like children. She shops for them and dresses them. She carries them when they need to be moved. She worries about their being harmed. As seen in her portrayals of the relationships of vents to their figures, her own rather maternal relationship is not the only one in evidence. She purposefully used the pejorative term "dummy," with its connotation of a blockhead, rather than the more respectful term "figure" for the males. The power and sexual dominance associated with the beautiful wife holding her dwarf husband is implicit in the artist's relationship with these figures.

By mounting the dummies on the wall in their chairs, Simmons moves the viewer into a specific relationship with the figure-sculptures. The viewer is not privileged to the same position of dominance. Viewer and dummy meet at eye level where the figures have the status of art objects, hanging mute on the wall at traditional painting height. In this body of work the only dialogue seems to be a private (and silent) one between the dummy and Simmons, rather than the dummy and viewer. By removing the figure from the photograph, Simmons does away with the photographer (the dummy's ventriloquist). The dummies' only punch line is their attire, and they sit speechless, dumb, and paralyzed before their audience.

Simmons later photographed her male dummies in the landscape, in sets, and against rear-projection backgrounds. The first images were romantic stagings of a single

dummy sitting in the sand dunes at the beach. In the series "Café of the Inner Mind" she took a more critical look at men. Instead of putting words into the dummies' mouths, she used a computer to collage memories or fantasies in cartoon balloons. The series drew on Simmons's memories of the exclusively male ventriloquist dialogues she had seen on television as a child. (She says she never even considered making her first dummy a female, so strong were her recollections of vents and dummies as male.) For *Café of the Inner Mind: Men's Room*, 1994, she had a set built for the dummies—a public restroom. This site for male fantasies is a "dirty" bathroom—except that men are not cleaning the bathroom as women did in the early "Interiors." The mental dialogue among the dummies has turned to what kind of ass each prefers; the dummies' thoughts, pictured in bubbles above their heads, are as crass as the ventriloquist dialogues she remembers. Simmons was "trying to deal with caricatures of male fantasy. The way I found them was by culling through hundreds of dirty pictures in pornographic magazines. The fantasies I gave them were based on my projections of what those guys would be thinking. It wasn't a very flattering view of men."

In a more wistful image, *Café of the Inner Mind: Mexico*, 1994, a dummy sits at the top of a dark, decrepit stairway dreaming of a festive evening in Mexico. The contrast between the dummy's physical and mental locations is dramatic and the viewer is left to ponder why his situation is so grim and what his reverie means. The longing in this melancholic picture, which draws such an empathetic response from the viewer, is typical of Simmons's best work.

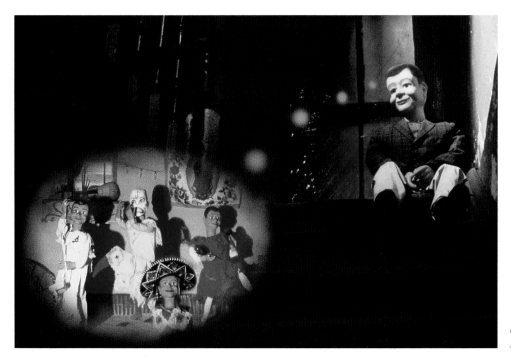

Café of the Inner Mind: Mexico. 1994. 35 x 53 in.

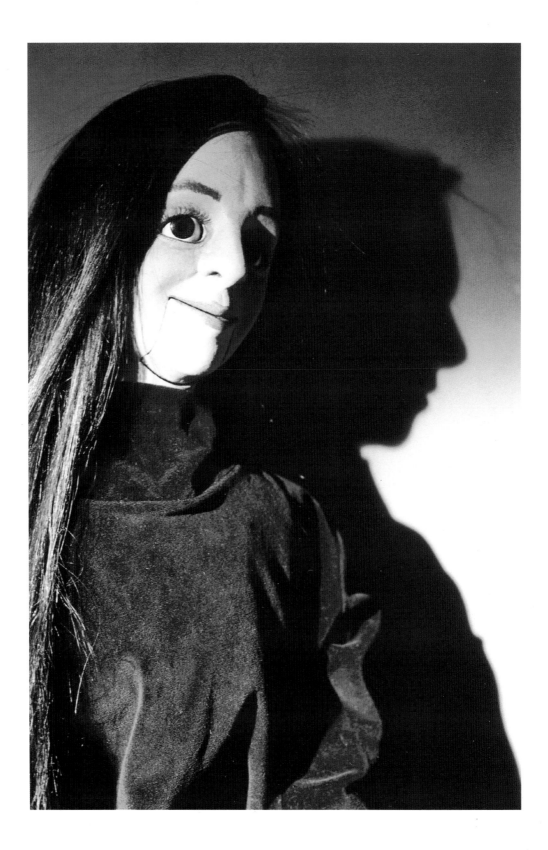

The Music of Regret I. 1994. 60 x 40 in.

THE MUSIC OF REGRET AND
THE UMBRELLAS OF CHERBOURG

I always knew I wanted to be an artist, and even given that, I spent a lot of my time when I was young wishing to be the wife or mistress of a great artist, for whom I would be a great muse. Pre-feminist thinking. Using my own image was about making this commitment to being this physical, emotional inspiration to myself. Having it be right out there, where I could own it. And I like that commitment to that idea, that I would be my own muse.[29]

In 1994 Simmons had a figure made in her own image that she photographed with her male dummies for the series "The Music of Regret."[30] In modeling a figure after herself, Simmons followed a ventriloquial tradition of twinning portrayed in many of the press shots she saw displayed at Vent Haven. This approach eliminated making decisions about what her female dummy should look like. The new figure, made with movable eyes and mouth, has the starring role in the group of four pictures which reach back to Simmons's adolescent years of yearning to be loved, to be popular, to be admired. The title reminds us how a song or melody can stir up memories, particularly of the sentimental years of young romance. *The Music of Regret II* and *III*, 1994, could depict prom night as Simmons's alter ego leans on the shoulder and stares into the eyes of a dummy in tuxedo. In *The Music of Regret IV*, 1994, the female is the center of attraction as all six male dummies encircle her. The scene seems choreographed for a musical production and, in fact, Simmons thought of it as a publicity photograph for a Broadway show. The most touching photograph in the series is *The Music of Regret I*, 1994, a three-quarter portrait with the shadow of the dummy's profile prominently seen in the background. Simmons, ever the illusionist, brings this figure to life through its shadow (it is uncanny how much the shadow looks like Simmons). Like earlier surrogates the artist has used, her alter ego is both girl and woman; her tentative smile and searching eyes are dreamy and yearning. The series overall reflects the tender ache of a teenage girl searching for the admiration of boys, and the foolishness of it all. Girls of Simmons's generation were led to believe that the admiration of men was the measure of female success. Of course as a child she would have aspired to be the great artist's wife rather than the great artist herself. "The Music of Regret" also reflects the constructive change, or liberation, that can come from the experience of regret. It was only in examining her deeply rooted desire to be the object of admiration, to be someone else's muse, that she resolved to become her own muse.

Regret and longing, the themes of the 1964 musical film *The Umbrellas of Cherbourg*, inspired Simmons's 1995 sculpture installation of the same title. She created

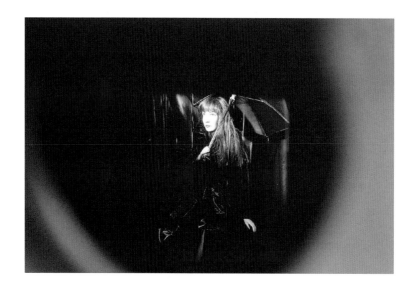

The Umbrellas of Cherbourg. 1996. Installation piece: dimensions site-specific.

this piece for the peephole exhibition space at Postmasters Gallery in New York where she transformed the Duchamp-inspired site into one for female rather than male fantasy. The film's famously sentimental sound track was audible as the viewer approached and saw through the peephole a three-foot mannequin made in Simmons's own likeness sitting in a raincoat and holding an umbrella under a spray of water. Creating the work was a fulfillment of Simmons's teenage fantasy of being Catherine Deneuve, the star of the film. "Seeing a film over and over when you're young [I]f you see it enough times, you have a loss of identity, and in a sense you start to feel you are trading places with the star, the heroine, the protagonist, or whoever the object of your identification is. You have such admiration for the actress playing the part that you wish to become her. The whole thing—to be in the movie, have her life outside the movie, the clothes, the hair, the makeup, everything." To this day some of Simmons's fondest memories are those of being on stage as a child. She loved acting and her focus on role-playing must stem from this early experience of role-playing and imagining the possible directions her life might take.

Regret is often a part of reminiscing about the past, particularly when appraising the course of a life and imagining what it might have been like had something been different. Simmons's interest in regret was focused by a 1994 article in *The New York Times*. She read about the psychological study that placed regret in a "'sadness grouping' along with disappointment, melancholia and discouragement." Other studies reported in the article placed regret in a "'personal responsibility grouping' which includes remorse, shame and guilt."[31] Regret has a broad range of meaning, from mere disappointment in not being able to do something, to a painful sense of loss, bitterness, or longing for something lost or done or left undone. Linked in the nineteenth century to nostalgia and longing for someone or something, today it rarely carries this bittersweet connotation and instead is thought of as an entirely unpleasant emotion. The greatest degree of pain may accompany regret when it entails self-blame, but regret also arises from situations over which we have no control. For Simmons, "regret is about lost opportunity, moments, or a lost life, and often regret focuses on things outside of our control."[32] Regret, particularly as it reflects the longing for lost opportunity and lost life experience, runs through her disquieting pictures of solitary and invisible women, from the "Interiors" begun in 1976 to *The Umbrellas of Cherbourg*. "The Music of Regret" could be the theme song for many of Simmons's theatrically-staged productions.

According to Janet Landman, a psychologist who has made regret the topic of her research, "regret is best apprehended as an emotion informed by reflective intelligence, as an interior matter with implications for exteriority, as a look at the past capable of informing and energizing the present, and as the insistence of the possible upon a hearing of the world in the actual."[33] Like regret, Simmons's working method is a process

of weighing and integrating the often contradictory impulses of emotion and intellect, interiority and exteriority, past and present, fact and fantasy. Through her rich and complex body of work, Simmons has translated the dialectical reading of her personal and collective memories into a dialogue about the influence of time, place, and social context on the development of self. Simmons's work exemplifies Landman's belief in personal development "as a historical, dialectical process in which (to paraphrase Kierkegaard) one lives forward and understands backward." [34]

With the move to figures in her own image, Simmons seems poised to investigate a more clearly autobiographical reading of her own memories and fantasies as typifying the sociocultural myths of the mid-to-late-twentieth century. This bodes well for her fictional work, as its psychological and emotional intensity has all along provided the strength of its resonance. With the work's simultaneous critical edge, always questioning cultural and interpersonal conventions, Simmons's pictured memories are also documents recording a revision of our history and a rewriting of our myths.

JAN HOWARD
Associate Curator, Prints, Drawings & Photographs
The Baltimore Museum of Art

NOTES

1. Simmons quoted in an interview with Dara Albanese, "Context of Scale," *Cover*, May 1990, 16. Quotations in the text not otherwise noted are from a taped conversation with the author on 19 August 1996. The artist generously shared her thoughts about the work throughout our collaboration which began in the spring of 1994. **2**. The thoughts on memory are gathered from June Crawford, Susan Kippax, Jenny Onyx, Una Gault, and Pam Benton, *Emotion and Gender: Constructing Meaning from Memory* (London: Sage Publications, 1992); John Kotre, *White Gloves: How We Create Ourselves Through Memory* (New York: The Free Press, 1995); Daniel Schacter, *Searching for Memory: The Brain, the Mind, and the Past* (New York: BasicBooks, 1996); and Jeffery A. Singer and Peter Salovey, *The Remembered Self: Emotion and Memory in Personality* (New York: The Free Press, 1993). The author wishes to thank Paul Roberts for his thoughtful and generous review of this essay. **3**. Simmons quoted in an interview with Sarah Charlesworth published in William S. Bartman and Rodney Sappington, eds., *Laurie Simmons* (Los Angeles: A.R.T. Press, 1994), 8. **4**. Simmons speaking about her work in *After Modernism: The Dilemma of Influence*, prod. and dir. by Michael Blackwood, 58 min., Michael Blackwood Productions, Inc., 1992, videocassette. **5**. Simmons quoted in an interview with Linda Yablonsky, *Bomb* (Fall 1996), 20. **6**. Crawford et al., *Emotion and Gender*, 188. **7**. Naomi Rosenblum discusses the development of color in modern photography in *A World History of Photography* (New York: Abbeville Press, 1989, revised edition), 493–495, 580–600, 610–611. **8**. Gaston Bachelard, *The Poetics of Space*, trans. Maria Jolas (Boston: Beacon Press, 1969), 6. **9**. Charlesworth interview, *Laurie Simmons*, 9. **10**. Simmons quoted in "Pictures that Tell the Truth by Making It Up," *Photography Year / 1981 Edition* (Alexandria, VA: Time-Life Books, 1981), 23. **11**. Robin Wood categorizes four main gender types in classic Hollywood cinema in the article "Ideology, Genre, Auteur," *Film Comment* 13, no. 1 (January–February 1977), 47, which is referenced in Julie Levinson's article "Genre and Gender: The Subversive Potential," *Double Vision: Perspectives on Gender and the Visual Arts* (London and Toronto: Associated University Presses, 1995), 139. **12**. Simmons speaking in "Laurie Simmons," *Crossover Series: Cindy Sherman, Richard Prince, Laurie Simmons*, dir. by Carole Ann Klonarides and Michael Owen, 5 min., The Television Network, New York, 1982, videocassette. **13**. So impressed was Simmons with the work that she went to an opening of an exhibition of Turbeville's photographs in order to meet her. She worked for her for a month pasting up a portfolio. **14**. Simmons contributed a short piece about the impact of films on her work in Paul Gardner, "Light, Canvas, Action! When Artists Go to the Movies," *ArtNews* 93, no. 10 (December 1994), 128. **15**. Simmons recorded in Blackwood, *After Modernism*. **16**. Simmons quoted in Charlesworth interview, *Laurie Simmons*, 16. **17**. This was an important point of Douglas Crimp's catalogue essay for his influential 1977 exhibition, "*Pictures*," at Artists Space in New York. *Pictures* (New York: Artists Space, 1977), 3. **18**. Simmons quoted in an interview with Cindy Sherman, "The Lady Vanishes," *Laurie Simmons* (Tokyo: Parco Vision Contemporary, 1987), 12. **19**. Simmons quoted in an interview with Allan McCollum by Beth Biegler, "Surrogates & Stereotypes," *East Village Eye*, December / January 1986, 64. **20**. It was not the first time Simmons had worked in collaboration. In 1984 she created a series of pictures with Sherrie Levine in which the "Teenettes" visited museum galleries via rear projection. **21**. The ventriloquist dialogue between Jimmy Nelson and Danny O'Day accompanied a slide presentation Simmons developed on her work for a symposium at the Wiener Secession, 19–20 October 1990, published in *Kunst in New York* (Vienna: Wiener Secession, 1990), 48–49. Simmons transformed the slide presentation into the video *Laurie Simmons: Filmstrip*, Bill Bartman, New York, 1997 as a project of A.R.T. Press. **22**. Yablonsky interview, *Bomb*, 19. **23**. Ibid. **24**. Ibid., 23. **25**. Blackwood, *After Modernism*. **26**. Bourgeois made a photogravure of the image, *Femme Maison (Woman House)*, in 1984. Only a handful of impressions were printed at that time. In 1990 Galerie Lelong in Paris published the print in an edition of sixty. **27**. The reference to Kurt Seligmann's *Ultra Meuble* was first made in Nicholas Jenkins's review of Simmons's 1991 exhibition of the "Walking and Lying Objects" published in *ArtNews* 91, no. 1 (January 1992), 119. **28**. Charlesworth interview, *Laurie Simmons*, 26. **29**. Yablonsky interview, *Bomb*, 23. **30**. The title for the series was inspired by the title of Paul Auster's novel *The Music of Chance* (Penguin Viking, 1990) and an article on regret by Lynda Edwards, "What Might Have Been," *The New York Times*, 2 January 1994, section 9, pages 1, 6. **31**. Quoted from Edwards's article, "What Might Have Been," 1. Other remarks on regret are based on Janet Landman's book, *Regret: The Persistence of the Possible* (New York and Oxford: Oxford University Press, 1993). **32**. Yablonsky interview, *Bomb*, 23. **33**. Quoted from Landman, *Regret: The Persistence of the Possible*, 264. **34**. Ibid., 25.

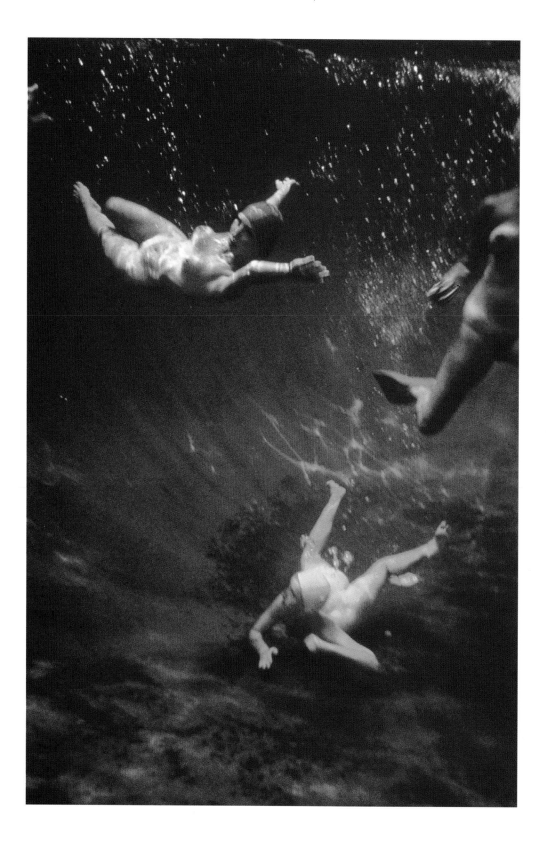

Swimming Women. 1980. 14¹/₁₆ x 9³/₁₆ in.

FROM *My Old Sweetheart*
SUSANNA MOORE

TŌSI BROUGHT THE JEEP to the front and they climbed in over the open sides. Anna noticed when the jeep lurched several times and stalled that Tōsi was wearing a pair of big, black lace-up shoes with no socks. Anna could see that the shoes were big enough so that he would not have had to untie the laces to slip them on.

Tōsi thought it was important to wear shoes when driving. He equated wearing shoes with being a man, although he himself was only twelve years old. He and Lily were the same age. They often had the same thoughts: Lily understood that he believed the shoes helped him to drive. But Anna did not know this. "Take off the shoes," she said.

"Why, Anna-san?"

"Because it is dangerous. If you do not, I will have to drive." Anna seldom used contractions. She spoke like someone who had learned English as a foreign language.

Tōsi removed the shoes unhappily and passed them over the seat to the children in the back, where Lily tried to find a large enough place to put them. Finally, she threw them over the side.

"Whose are they anyway?" she shouted, but they were moving at last, and he could not hear her.

It was the middle of summer. The black volcanic ridges and their deep, green valleys looked like the folds of an old velvet gown. Along the road, the sea was loud as it foamed white water against the lacy lava rock. The light and the moisture in the air made colors bright and true.

When they reached the end of the road, Tōsi parked jerkily under a casuarina tree. He said he would wait for them. He did not like the Cave. He would pick opihi instead. Anna and Jack and Lily were excited. They did not answer Tōsi, but jumped eagerly out of the jeep and went hurriedly through the sea grape.

When they reached the water, they had to scramble like monkeys over the wet rocks. There was a fishy smell of stale salt water. Lily saw Jack slip on the sharp, porous rock. He stopped to study his foot carefully for signs of blood. Their mother was ahead of them. She did not look back, even when Jack called out. She is not the kind who bandages cuts, Lily thought. She is not like other mothers, who make grocery lists and wear undergarments. Other mothers do not forget that you go back to school in September, but other mothers, she thought, don't go into underground caves either. Although she preferred her mother, sometimes she was frightened.

Anna was already in the water. Using his rock scratches as an excuse, Jack yelled that he would wait with Tōsi. Lily waved and dived into the ocean.

She followed Anna's black head, round and shiny like a seal now that her hair was wet, bobbing through the green water, to the rocks at the base of the cliff. Anna's head went under. She did not come up. Big, round bubbles floated up slowly between Lily's legs and popped around her. She took extra air into her lungs and then she too disappeared beneath the surface.

Under water, pale green, it was suddenly silent as Lily followed a delicate trail of effervescence. She let some air rumble slowly out of her nose, saving the rest. The bubbles rose up past her open eyes. Her mother was gone. Lily slid herself along the spiky wall of rock, arms outstretched to keep from being thrown against it by the current. She found the cleft in the lava wall, felt for the opening in the rock, and quickly pulled herself inside.

At once she felt the temperature of the suddenly black water change. It grew colder and colder as she nervously kicked herself back up to the surface. She came up in darkness, spouting loudly, and breathed the cool, damp air. She was inside the Wet Cave. It was black all around her. There was not even a reflection on the water.

"Isn't it beautiful?" she heard her mother whisper. Her voice echoed. Lily could not see her in the dark. They were inside the mountain in a high, vaulted cavern washed hollow for thousands of years by the sea. Hundreds of tiny pinholes in the lava dome arching above them let in constellations of light. It was like the clear night sky. There were too many sparks to be stars alone: lightning bugs, thought Lily.

"Where are you?" she asked.

She felt the inky water move around her and then a hand splashed behind her and she found her mother's arm.

"Are you afraid?"

Lily didn't answer. She was always a little afraid in the Cave, no matter how many times she had been there. She could just make out the shape of her mother's round head next to her. There was the sound of wings beating. She kept looking around to make sure that the small, green circle of light, the opening to the world, was still beneath them in the water.

"It is really like being on the very edge of the planet," Anna said exultantly.

Lily's legs began to tire from treading water. The water was cold. She began to lose her senses. It became impossible to judge distances—the distance from her to Anna and the distance from minute to minute. It made her dizzy. The pull of the tide rocked them gently, just enough to make the mock stars above them change position. There was a story about two boys who had been caught in the Cave when the neap tide was coming in. They were unable to find their way out through the green hole in the rising water. Lily wondered what it must have been like, feeling yourself move higher and higher into the night sky. Their dead bodies were marked with hundreds of little pricks where they had been crushed against the lava.

Lily said, "I'm getting tired, Mother."

Anna spoke as though she had been startled. "Oh, my old sweetheart."

Lily heard her mother take in air, then the splash of her kick, then it was more silent than before. She floated on her back. She was alone in the Wet Cave. She turned over to watch the green light flicker off and on as Anna wiggled through the hole on her way back into the world, then she too dived down into it and smiled as she felt the stream of warm, living sea slide over her.

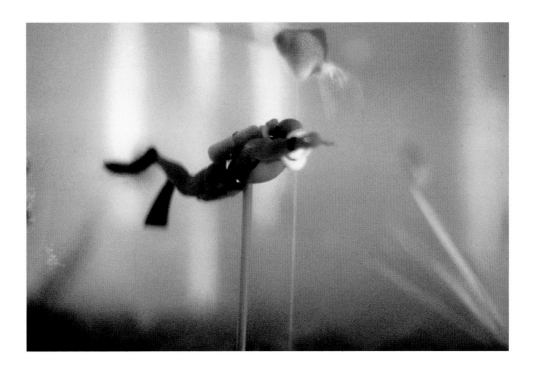

Murky Diver. 1979. 9 x 13½ in.

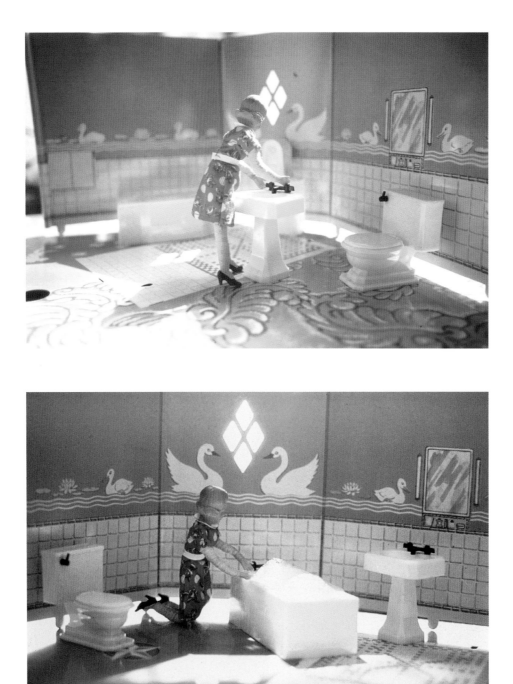

First Bathroom/Woman Standing. 1978. 3³⁄₁₆ x 5 in.
New Bathroom/Woman Kneeling/First View. 1979. 3³⁄₈ x 4¹³⁄₁₆ in.

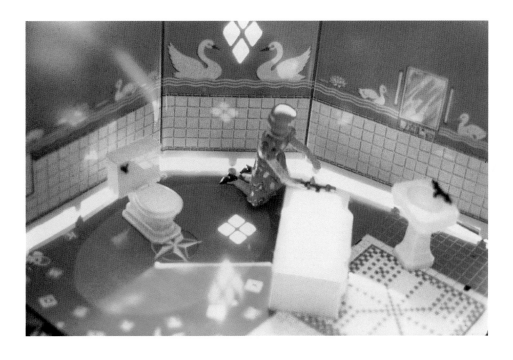

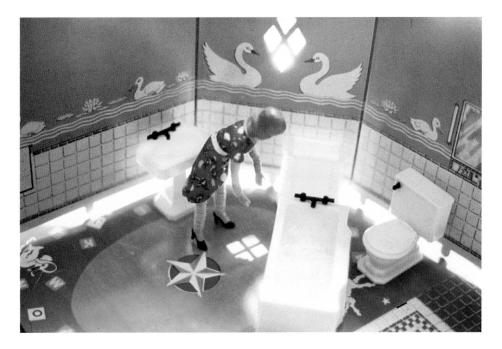

New Bathroom/Woman Kneeling/Second View. 1979. 3⅜ x 4¹³⁄₁₆ in.
New Bathroom/Woman Standing. 1979. 3⁵⁄₁₆ x 4⅞ in.

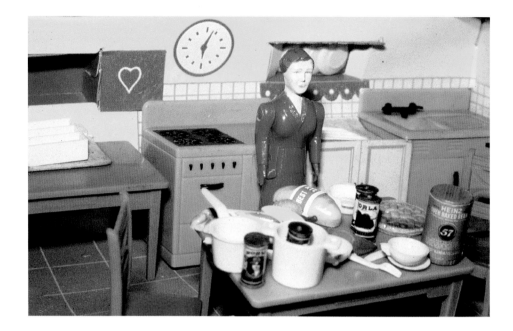

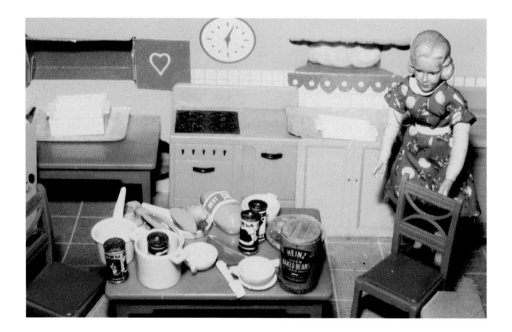

Purple Woman / Kitchen / Second View. 1978. 3¼ x 4¹⁵⁄₁₆ in.
Blonde / Red Dress / Kitchen. 1978. 3⅜ x 5 in.

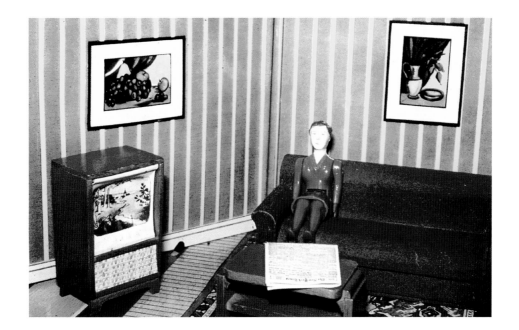

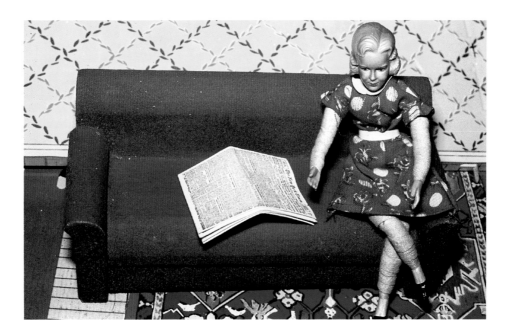

Woman Watching TV. 1978. 3¹⁵⁄₁₆ x 5⅝ in.
Woman / Red Couch / Newspaper. 1978. 3³⁄₁₆ x 4⅞ in.

The Garden

GARRETT KALLEBERG

The sun is low & the room is empty.
Not any room but your room.
You sit in your room which is empty, and
you imagine it to be empty. Which it is not.

A daydream fills your mind, a novel
& agreeable passion, perhaps you are not quite happy
in your room. Perhaps you would like
a beaver hat, peppercorns, fine silk, gunpowder—

black tea, cardamom—deerskin, sugar—
a new sealskin for the ballroom—a new
chart for the map room—a new philosophy
for the bedroom—a new Venus for the garden—

"Chase the Vices from the Garden."
One cultivates one's own garden. The garden
is out the window—it is not
your garden. The garden

is empty. It's winter.
Winter is empty, it's spring.

Late spring or summer and
the sun is low and the window is closed

and the air conditioner is on
and all of life

is buzzing around your head.
Your life. No need to go to sea.

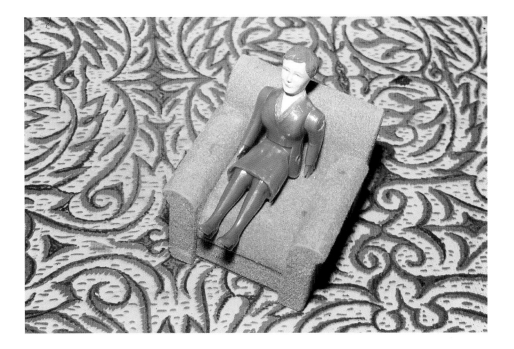

Woman/Gray Chair/Green Rug. 1978. 3⅜ x 5 in.

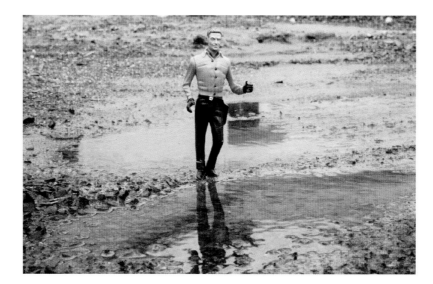

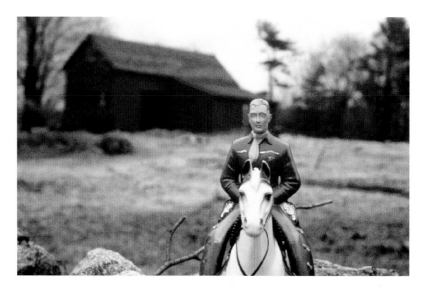

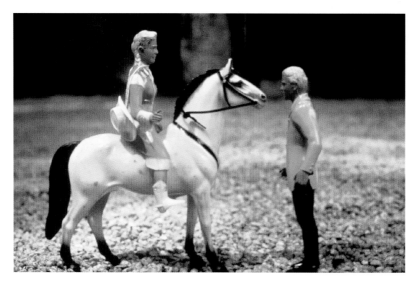

Man/Puddle. 1979. 5 x 7¼ in.
Man/Blue Shirt/Red Barn. 1979. 5 x 7³⁄₁₆ in.
Horizontal Man/Woman/Horse. 1979. 4¹⁵⁄₁₆ x 7⁵⁄₁₆ in.

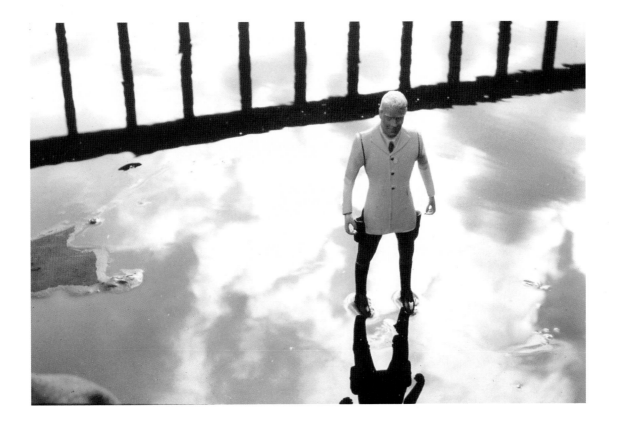

Man / Sky / Puddle (Second View). 1979. 4¹³⁄₁₆ x 7¼ in.

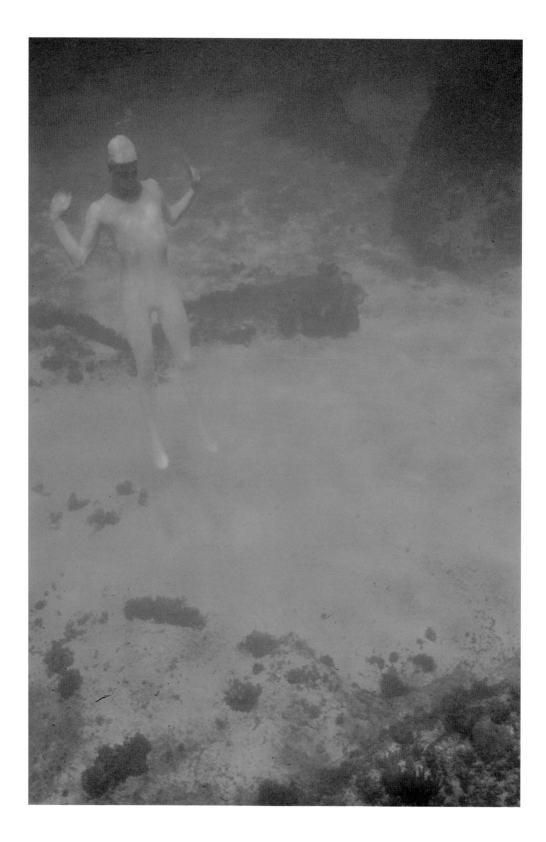

White Man Coming. 1981. 13¹¹⁄₁₆ x 9⁷⁄₁₆ in.

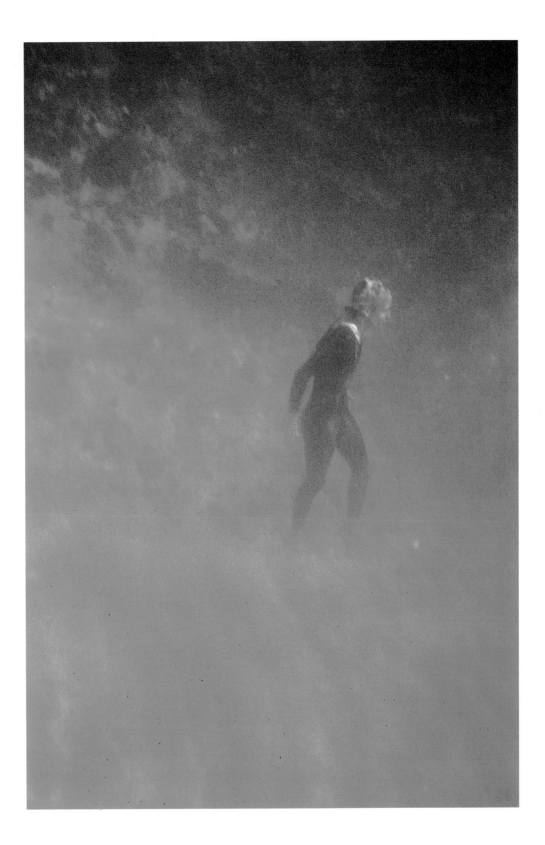

Red Man Going. 1981. 13¹¹⁄₁₆ x 9⁵⁄₁₆ in.

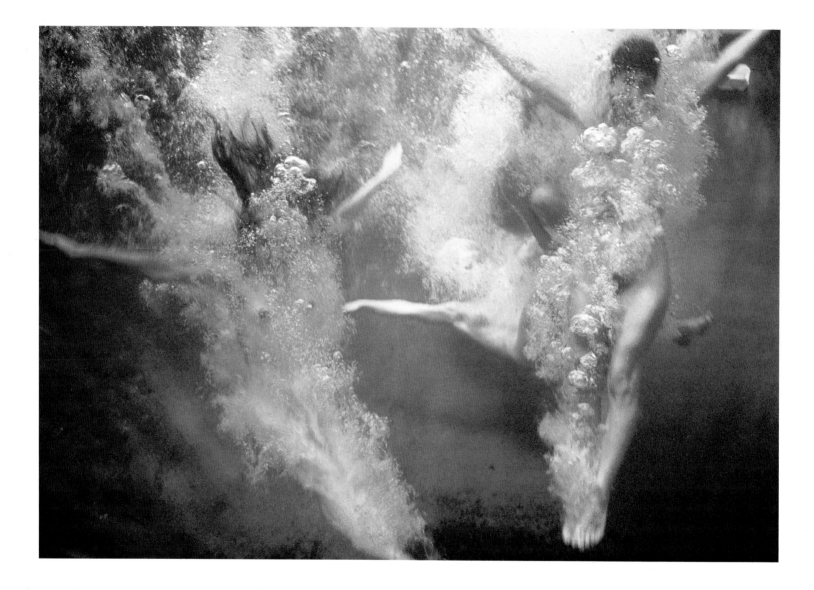

Splash. 1980. 16½ x 23½ in.

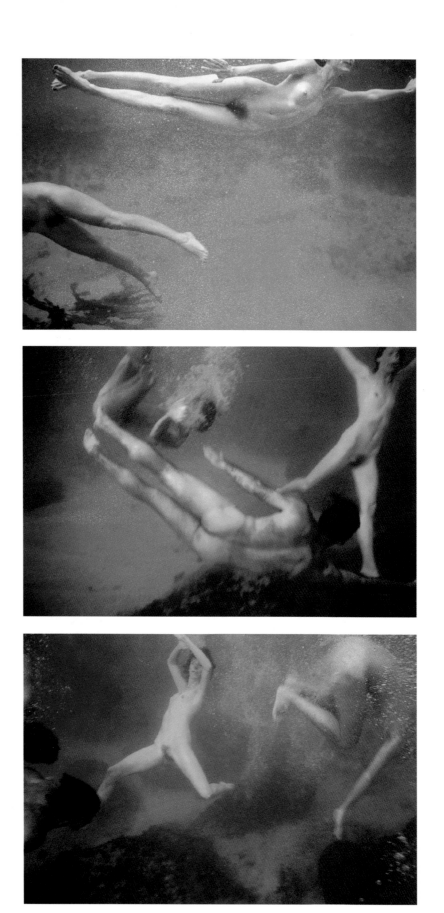

Calumny (Detail Truth). 1981. 13 x 19½ in.
Calumny (The Shrug, The Hum, The Ha). 1981. 13 x 19⅜ in.
Calumny (Parade). 1981. 13¹⁄₁₆ x 19½ in.

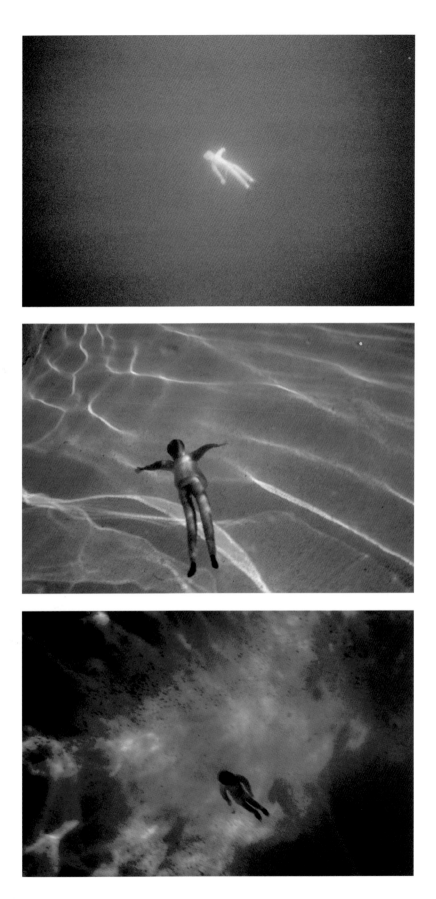

Boy/Bottle Green Background. 1981. 6⁷⁄₁₆ x 9⁹⁄₁₆ in.
Folded Man/Bottom Pool. 1981. 6⁵⁄₈ x 9⁹⁄₁₆ in.
Ethereal Boy. 1981. 6½ x 9⁷⁄₁₆ in.

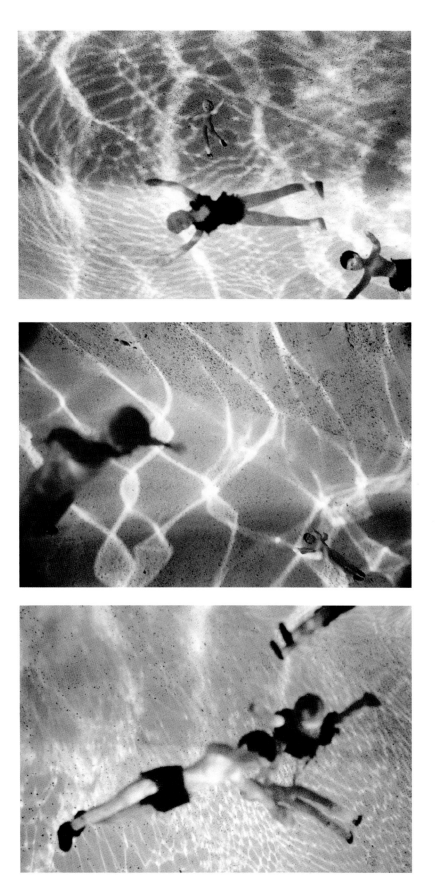

Horizontal Family (Baby Falling). 1981 15½ x 23 in.
Son Waving to Father. 1981. 15¼ x 22¼ in.
Family Collision (Legs). 1981. 15¼ x 22¼ in.

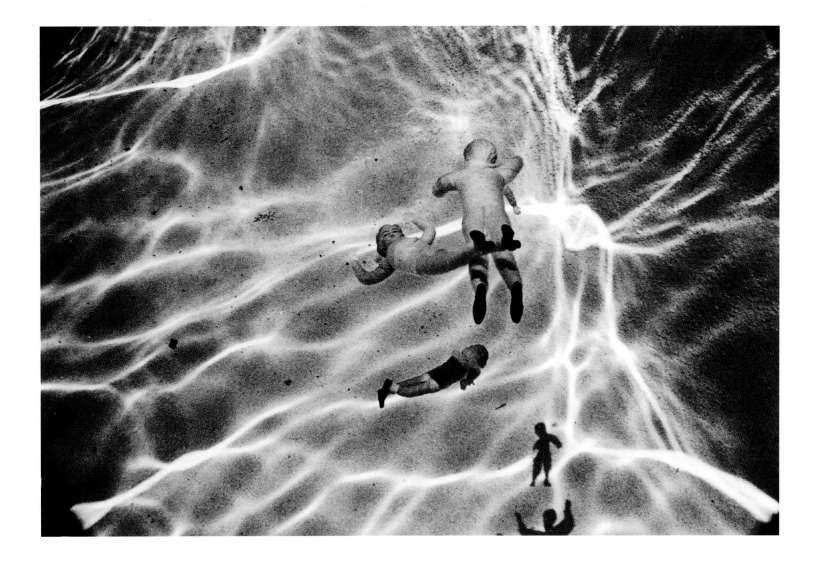

Family (Shadows). 1981. 15¼ x 22¼ in.

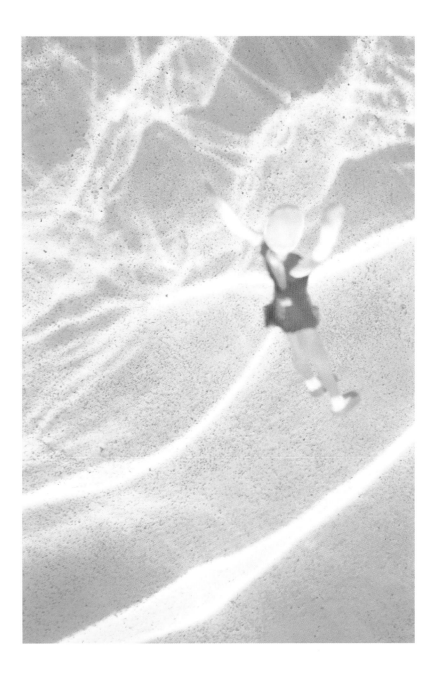

Blonde Falling. 1981. 9⁹⁄₁₆ x 6½ in.

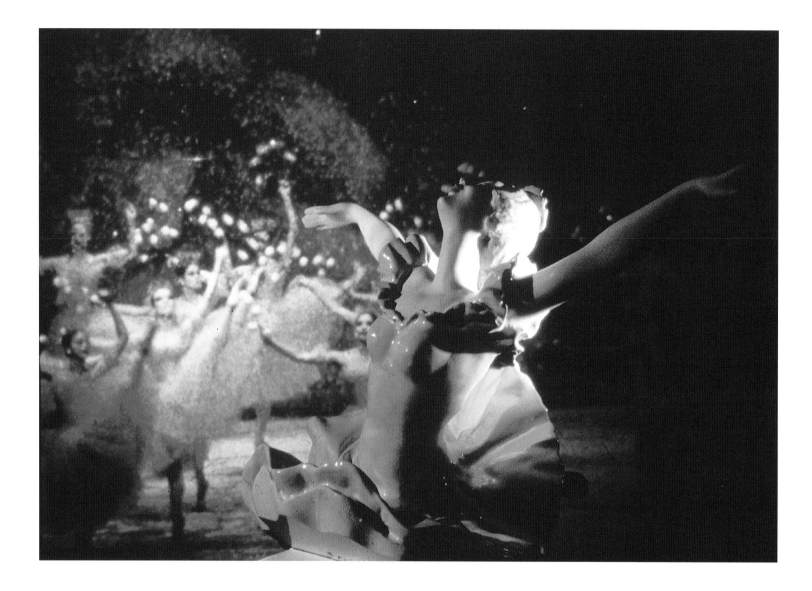

Waltz of the Snowflakes. 1983. 26¾ x 40 in.

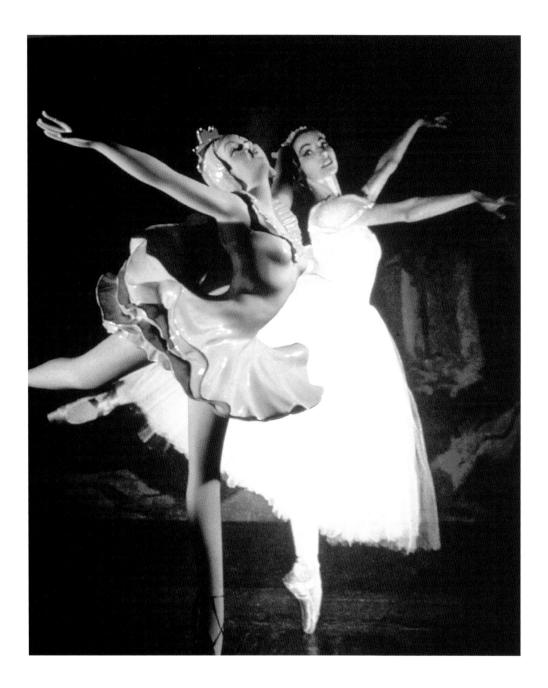

Untitled. 1983. 36 x 30 in.

A SIMPLE SHOE

A

SIMPLE

SHOE

WOULD FIT

ON

ANY

FOOT

IF

THE

SIMPLE

SHOE

WAS ANY SIZE.

JIMMY DESANA

White Shoes / Black Room. 1978. 3⁵⁄₁₆ x 4¾ in.

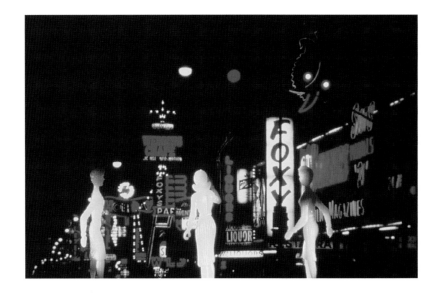

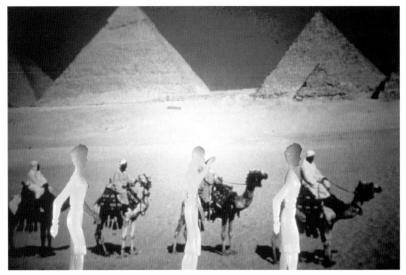

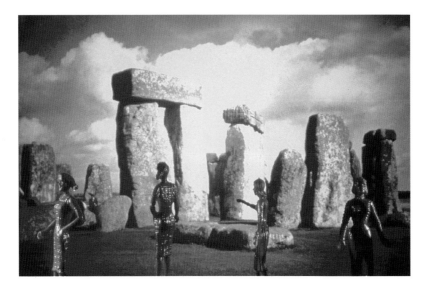

Tourism: Las Vegas. 1984. 40 x 60 in.
Tourism: Pyramids. 1984. 40 x 60 in.
Tourism: Pink Stonehenge. 1984. 40 x 60 in.

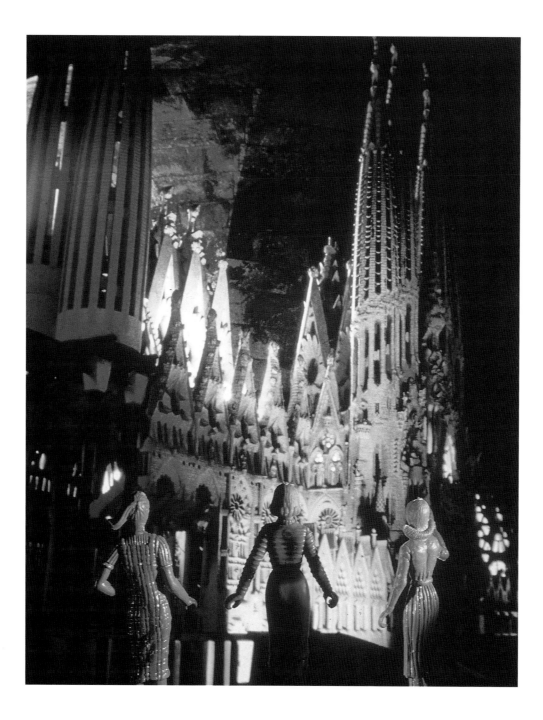

Tourism: Barcelona. 1984. 60⅜ x 40⅛ in.

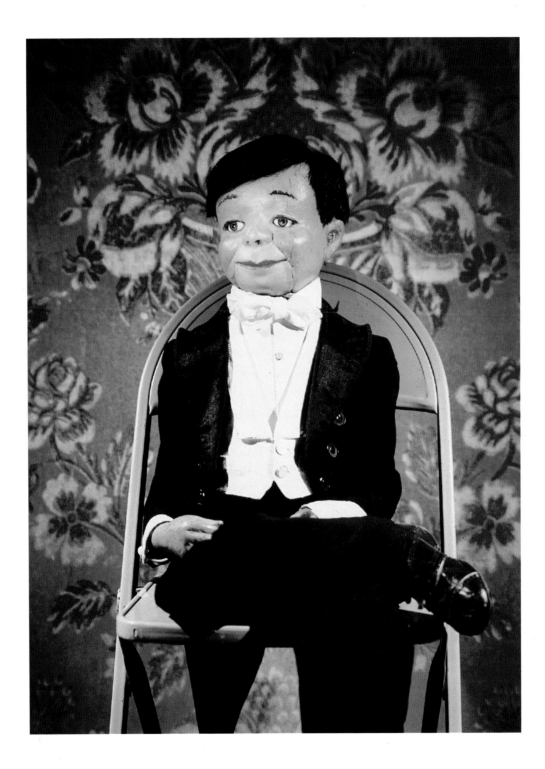

The Frenchman (Mickey). 1987. 35 x 25 in.

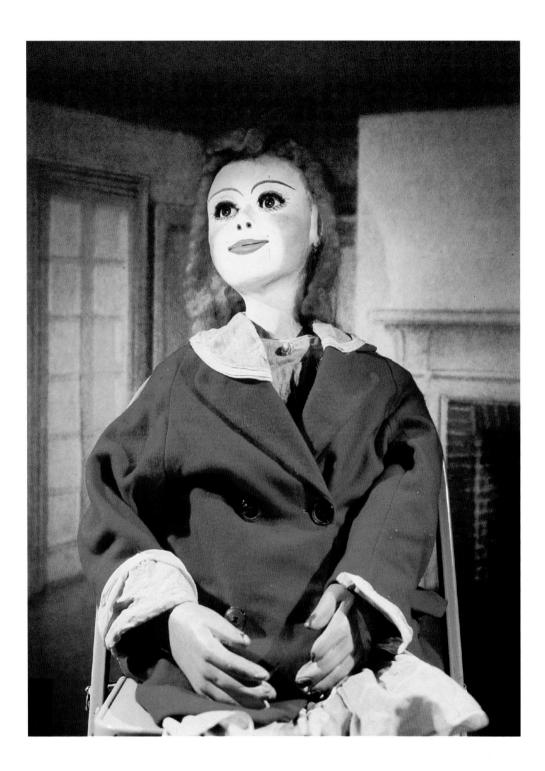

English Lady. 1987. 35 x 25 in.

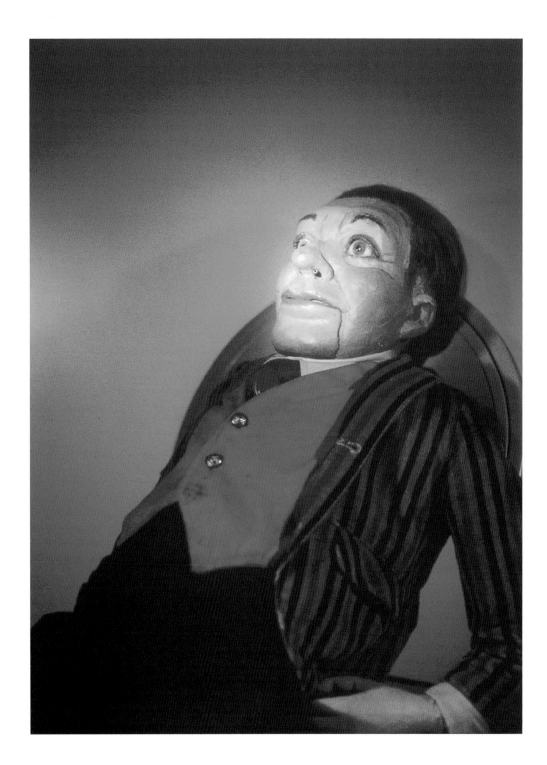

Pancho. 1988. 35 x 25 in.

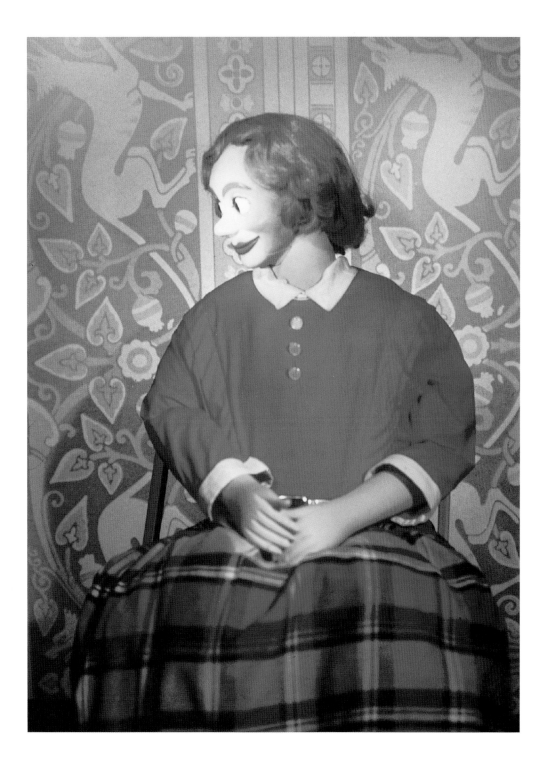

Jane. 1988. 35 x 25 in.

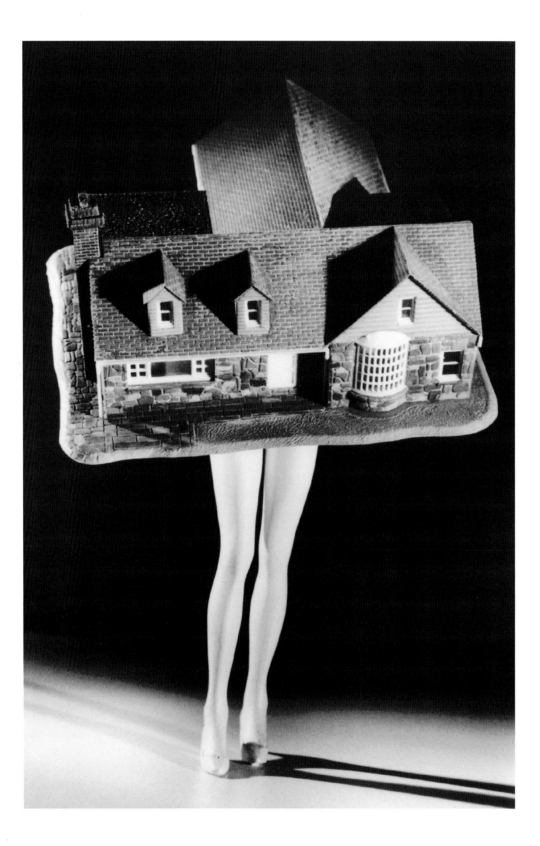

Walking House. 1989. 83¼ x 47⅜ in.

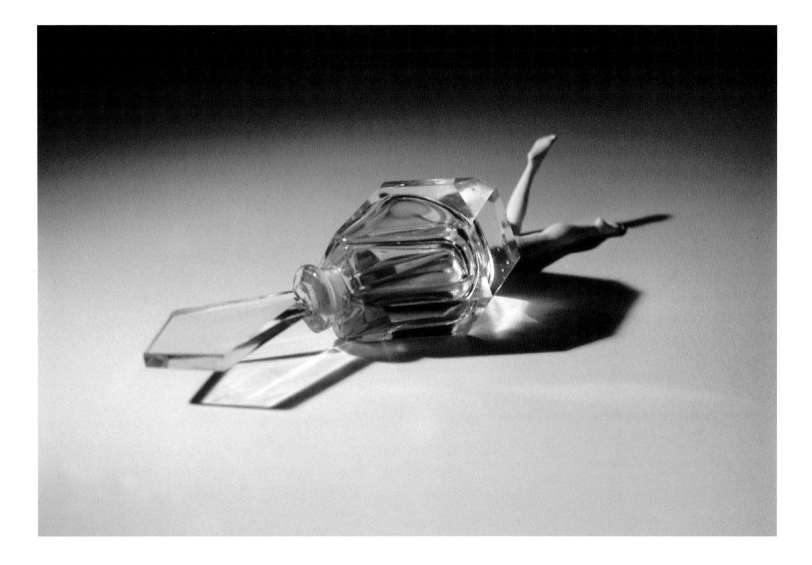

Lying Perfume Bottle. 1990. 48 x 84 in.

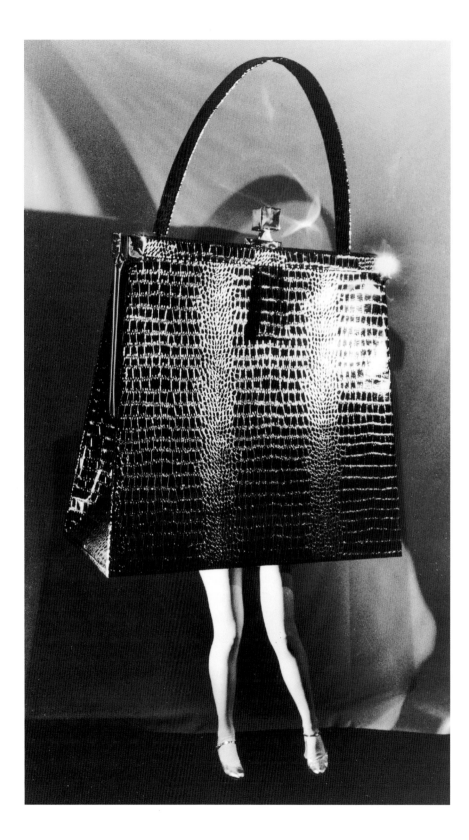

Walking Purse. 1989. 84 x 48 in.

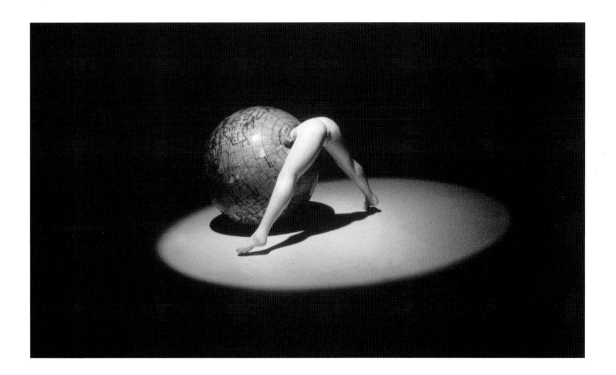

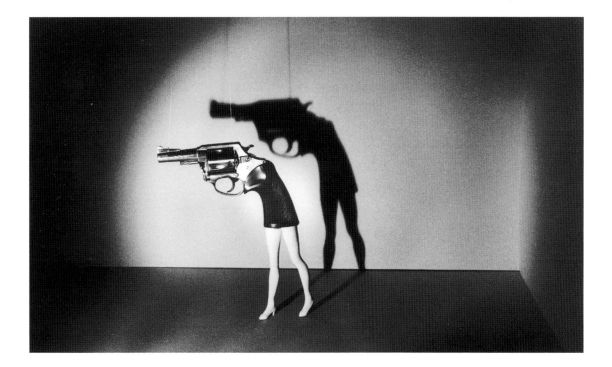

Bending Globe. 1991. 48 x 84 in.
Walking Gun. 1991. 48 x 84 in.

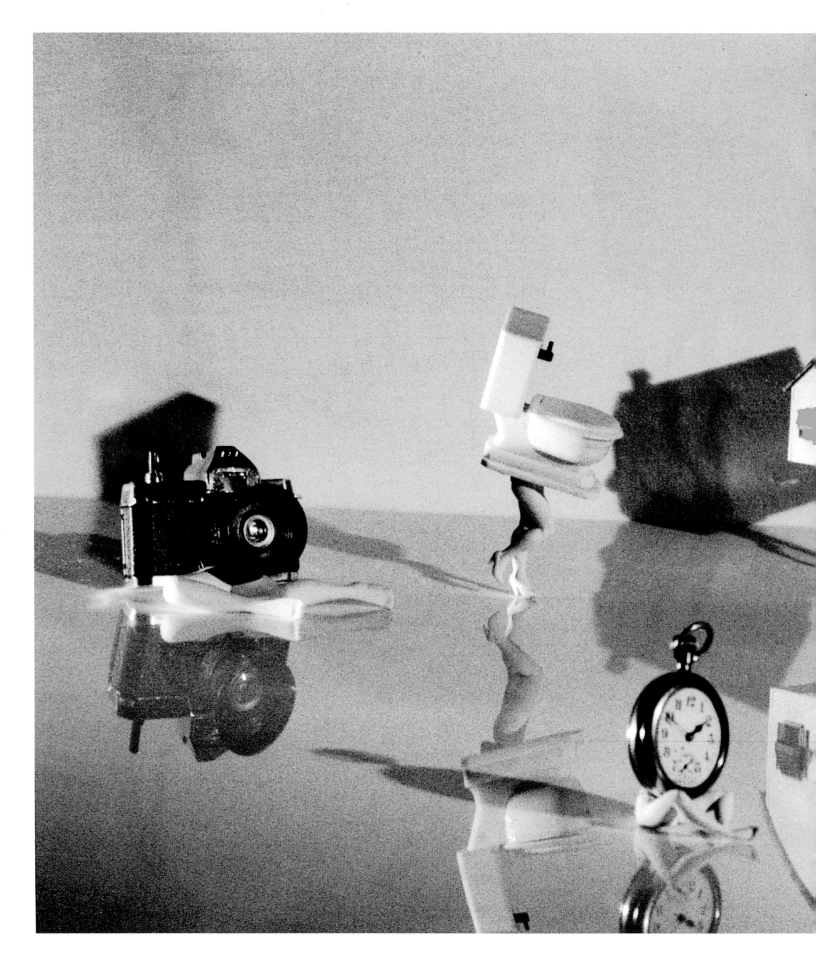

Magnum Opus (The Bye-Bye). 1991. 101¼ x 240⅝ in.

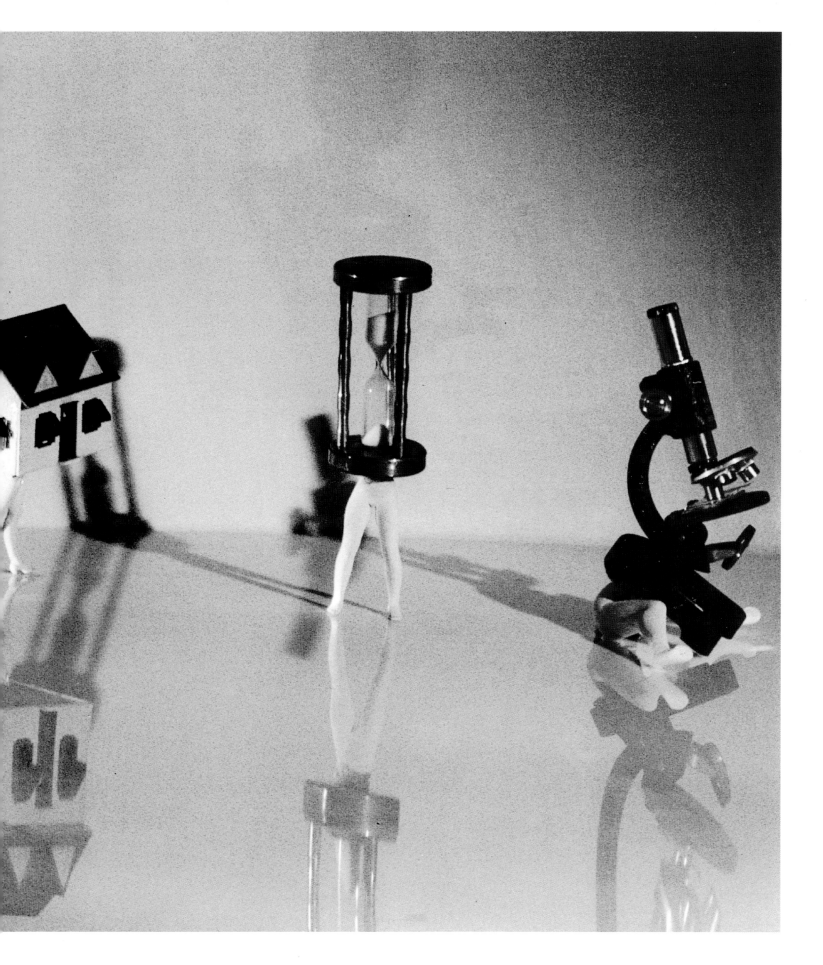

FROM: "Ladies and Gentlemen…
the Nicest Kids in Town!"

JOHN WATERS

If I have one regret in life, it's
that I wasn't a Buddy Deaner.
Sure, as a teenager I was a guest
on this Baltimore show. I even
won the twist contest with Mary
Lou Raines (one of the *queens* of
"The Buddy Deane Show") at a
local country club.

But I was never a Deaner.
Not a real one. Not one of the
Committee members, the ones
chosen to be on the show every
day—the Baltimore version of
the Mouseketeers, "the nicest
kids in town," as they were
billed. The guys who wore sport
coats with belts in the back from
Lee's of Broadway (ten percent
discount for Committee mem-
bers), pegged pants, pointy-toe
shoes with the great buckles on
the side and "drape" (greaser)
haircuts that my parents would
never allow. And the girl
Deaners, God, "hair-hoppers" as
we called them in my neighbor-
hood, the ones with the Etta
gowns, bouffant hairdos and cha-
cha heels. These were the first
role models I knew. The first
stars I could identify with.
Arguably the first TV celebrities
in Baltimore.

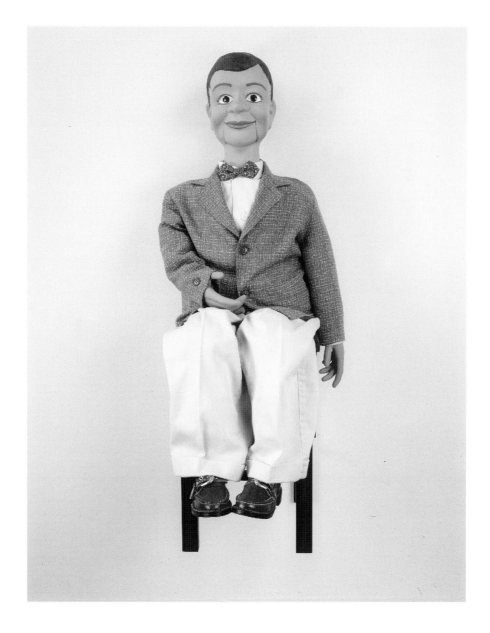

Clothes Make the Man (don't I know it). 1990–1991.
Mixed media. 39½ x 12 x 15 in.

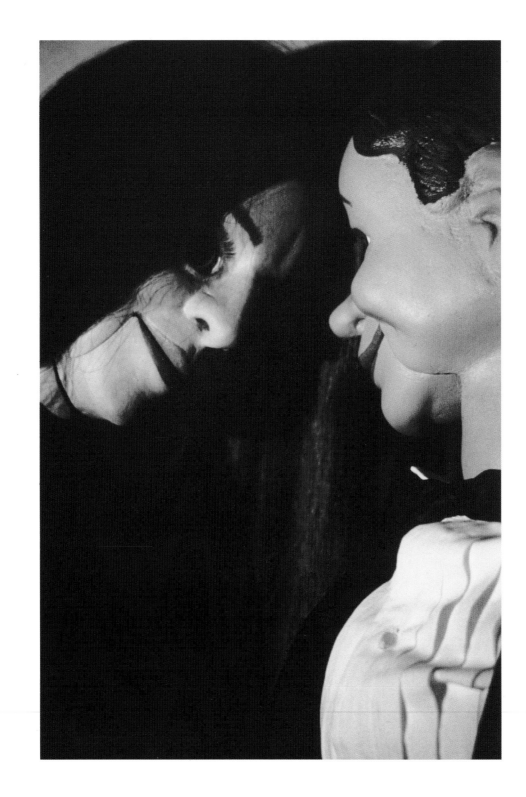

The Music of Regret III. 1994. 60 x 40 in.

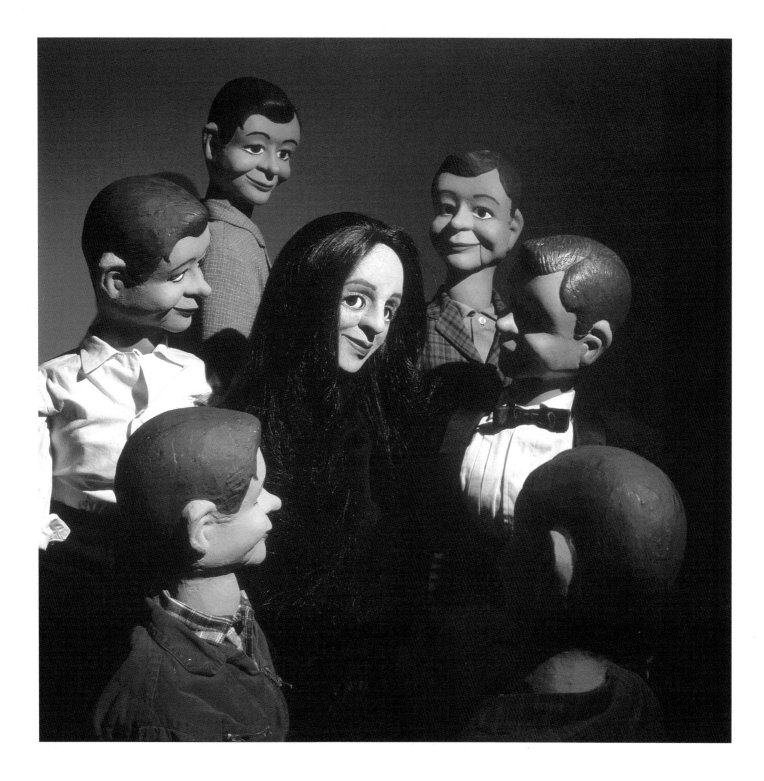

The Music of Regret IV. 1994. 84 x 84 in.

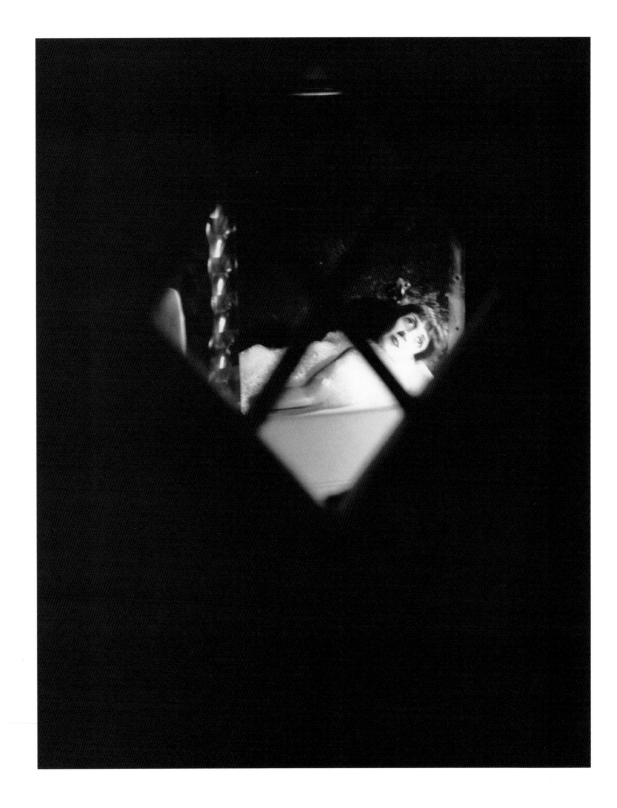

Black Bathroom / View through Window, March 26, 1997. 1997. 40 x 30 in.

EXHIBITION LIST

Dimensions are given in inches and millimeters or centimeters, height preceding width preceding depth. Dimensions given for photographs are image size. Dates in parentheses do not appear on works. The photographs made through 1981 appear in different sizes within the same edition. Except as noted, all works are Collection the Artist, courtesy Metro Pictures, New York.

INTERIORS

1. *Sink/Connecticut*. 1976. Gelatin silver print. 7 x 4¾ in. (178 x 121 mm.). From an edition of 10.

2. *Sink/Ivy Wallpaper*. 1976. Gelatin silver print. 4¹¹⁄₁₆ x 6⅞ in. (119 x 175 mm.). From an edition of 10.

3. *Refrigerator/Wallpaper*. 1976. Gelatin silver print. 4¾ x 7¹⁄₁₆ in. (120 x 179 mm.). From an edition of 10.

4. *Bathroom I*. (1976). Gelatin silver print. 7⅞ x 11⅝ in. (199 x 296 mm.). From an edition of 10.

5. *Bathroom II*. (1976). Gelatin silver print. 8¹⁄₁₆ x 12 in. (205 x 304 mm.). From an edition of 10.

6. *Bathroom III*. (1976). Gelatin silver print. 8¹⁄₁₆ x 11¹⁵⁄₁₆ in. (205 x 303 mm.). From an edition of 10.

7. *Bathroom IV*. (1976). Gelatin silver print. 8¹⁄₁₆ x 11¹⁵⁄₁₆ in. (205 x 303 mm.). From an edition of 10.

8. *Living Room/Bathroom/Abstract*. (1976). Gelatin silver print. 8¹⁄₁₆ x 12 in. (205 x 304 mm.). From an edition of 10.

9. *Living Room/Bathroom II*. (1976). Gelatin silver print. 11 x 14 in. (279 x 355 mm.). From an edition of 10. The Museum of Modern Art, New York, Joel and Anne Ehrenkranz Fund, 672.94.

10. *Mother/Nursery*. (1976). Gelatin silver print. 7¹³⁄₁₆ x 5¼ in. (198 x 135 mm.). From an edition of 10.

11. *Untitled/Woman's Head*. 1976. Gelatin silver print. 8¹⁵⁄₁₆ x 13⅜ in. (227 x 339 mm.). From an edition of 10.

12. *Woman Watching TV*. 1978. Silver-dye-bleach print (Cibachrome). 3¹⁵⁄₁₆ x 5⅝ in. (100 x 143 mm.). From an edition of 7.

13. *Woman/Red Couch/Newspaper*. 1978. Silver-dye-bleach print (Cibachrome). 3³⁄₁₆ x 4⅞ in. (81 x 124 mm.). From an edition of 7.

14. *Woman Reading Newspaper*. 1978. Silver-dye-bleach print (Cibachrome). 3³⁄₁₆ x 4⅞ in. (80 x 123 mm.). From an edition of 7.

15. *Woman/Gray Chair/Green Rug*. 1978. Silver-dye-bleach print (Cibachrome). 3⅜ x 5 in. (85 x 126 mm.). From an edition of 7. Private Collection, Baltimore.

16. *Purple Woman/Kitchen/Second View*. (1978). Silver-dye-bleach print (Cibachrome). 3¼ x 4¹⁵⁄₁₆ in. (83 x 122 mm.). From an edition of 7. Collection Mel Bochner and Lizbeth Marano, New York.

17. *Blonde/Red Dress/Kitchen*. 1978. Silver-dye-bleach print (Cibachrome). 3⅜ x 5 in. (85 x 126 mm.). From an edition of 7.

18. *First Bathroom/Woman Standing*. 1978. Silver-dye-bleach print (Cibachrome). 3³⁄₁₆ x 5 in. (81 x 126 mm.). From an edition of 7.

19. *First Bathroom/Woman Kneeling*. 1978. Silver-dye-bleach print (Cibachrome). 3⁵⁄₁₆ x 4⅞ in. (84 x 124 mm.). From an edition of 7.

20. *First Bathroom/Woman Standing Left*. 1978, printed 1997. Silver-dye-bleach print (Ilfochrome). 3⅛ x 4¾ in. (80 x 121 mm.). From an edition of 7.

21. *First Bathroom/Woman Standing/Vertical*. (1978, printed 1997). Silver-dye-bleach print (Ilfochrome). 3 x 4¾ in. (76 x 120 mm.). (First printing for this exhibition.) From an edition of 7.

22. *Bathroom Plan*. 1978. Silver-dye-bleach print (Cibachrome). 3³⁄₁₆ x 4¹³⁄₁₆ in. (81 x 122 mm.). From an edition of 7.

23. *New Bathroom/Woman Standing*. 1979. Silver-dye-bleach print (Cibachrome). 3⁵⁄₁₆ x 4⅞ in. (84 x 124 mm.). From an edition of 7.

24. *New Bathroom/Woman Kneeling/First View*. 1979. Silver-dye-bleach print (Cibachrome). 3⅜ x 4¹³⁄₁₆ in. (86 x 123 mm.). From an edition of 7.

25. *New Bathroom/Woman Kneeling/Second View*. 1979. Silver-dye-bleach print (Cibachrome). 3⅜ x 4¹³⁄₁₆ in. (86 x 122 mm.). From an edition of 7.

BLACK SERIES

26. *Worgelt Study*. 1977. Silver-dye-bleach print (Cibachrome). 3¼ x 4⅞ in. (82 x 123 mm.). From an edition of 7.

27. *Red Couch/Gray Chair/Borghese Garden*. 1977. Silver-dye-bleach print (Cibachrome). 3⁵⁄₁₆ x 5⁵⁄₁₆ in. (85 x 135 mm.). From an edition of 7.

28. *White Shoes/Black Room*. (1978, printed 1996). Silver-dye-bleach print (Ilfochrome). 3⁵⁄₁₆ x 4¾ in. (85 x 121 mm.). From an edition of 7. Private Collection, Baltimore.

THE BIG FIGURES

29. *Brothers/Hay*. 1979. Silver-dye-bleach print (Cibachrome). 4¹¹⁄₁₆ x 7⅛ in. (119 x 181 mm.). From an edition of 7.

30. *Brothers/Horizon*. 1979. Silver-dye-bleach print (Cibachrome). 4¹⁵⁄₁₆ x 7½ in. (126 x 191 mm.). From an edition of 7.

31. *Brothers/No Horizon*. 1979. Silver-dye-bleach print (Cibachrome). 5 x 7⁵⁄₁₆ in. (128 x 186 mm.). From an edition of 7.

32. *Brothers/Aerial View*. 1979. Silver-dye-bleach print (Cibachrome). 5 x 7¼ in. (128 x 185 mm.). From an edition of 7.

33. *Man/Puddle*. 1979. Silver-dye-bleach print (Cibachrome). 5 x 7¼ in. (128 x 184 mm.). From an edition of 7.

34. *Man/Sky/Puddle (Second View)*. 1979, printed 1997. Silver-dye-bleach print (Ilfochrome). 4¹³⁄₁₆ x 7¼ in. (123 x 184 mm.). From an edition of 7.

35. *Man/Blue Shirt/Red Barn*. 1979. Silver-dye-bleach print (Cibachrome). 5 x 7³⁄₁₆ in. (127 x 182 mm.). From an edition of 7.

36. *Horizontal Man/Woman/Horse*. (1979). Silver-dye-bleach print (Cibachrome). 4¹⁵⁄₁₆ x 7⁵⁄₁₆ in. (125 x 185 mm.). From an edition of 7.

UNDER THE SEA

37. *Abstract Diver*. 1979. Silver-dye-bleach print (Cibachrome). 9 x 13½ in. (228 x 343 mm.). Edition 1/7.

38. *Black Diver*. 1979. Silver-dye-bleach print (Cibachrome). 6⅛ x 9⅛ in. (156 x 232 mm.). From an edition of 7.

39. *Murky Diver*. 1979. Silver-dye-bleach print (Cibachrome). 9 x 13½ in. (228 x 342 mm.). From an edition of 7.

40. *Diver Stage*. 1979. Silver-dye-bleach print (Cibachrome). 6 x 9½ in. (153 x 241 mm.). Edition 1/7.

WATER BALLET

41. *Swimming Women*. (1980). Silver-dye-bleach print (Cibachrome). 14¹⁄₁₆ x 9³⁄₁₆ in. (355 x 235 mm.). From an edition of 10.

42. *Bullet*. 1980. Silver-dye-bleach print (Cibachrome). 7¹⁵⁄₁₆ x 12⅞ in. (221 x 327 mm.). From an edition of 10.

43. *Walking Underwater*. (1980). Silver-dye-bleach print (Cibachrome). 17 x 23 in. (432 x 584 mm.). From an edition of 10.

44. *Splash*. (1980). Silver-dye-bleach print (Cibachrome). 16½ x 23½ in. (419 x 597 mm.). Edition 6/10. Collection Julia Scully, New York.

45. *White Man Coming*. 1981. Silver-dye-bleach print (Cibachrome). 13¹¹⁄₁₆ x 9⁷⁄₁₆ in. (348 x 240 mm.). Edition 3/10.

46. *Red Man Going*. 1981. Silver-dye-bleach print (Cibachrome). 13¹¹⁄₁₆ x 9⁵⁄₁₆ in. (348 x 236 mm.). From an edition of 10.

47. *Calumny (The Shrug, The Hum, The Ha)*. 1981. Silver-dye-bleach print (Cibachrome). 13 x 19⅜ in. (330 x 492 mm.). From an edition of 10.

48. *Calumny (Detail Truth)*. (1981). Silver-dye-bleach print (Cibachrome). 13 x 19½ in. (330 x 494 mm.). From an edition of 10.

49. *Calumny (Parade)*. (1981). Silver-dye-bleach print (Cibachrome). 13¹⁄₁₆ x 19½ in. (331 x 494 mm.). From an edition of 10.

50. *Flying Man (Red Suit)*. 1981. Silver-dye-bleach print (Cibachrome). 15¼ x 22¾ in. (387 x 579 mm.). From an edition of 10.

51. *Water Ballet (Vertical)*. 1981 (printed 1996). Silver-dye-bleach print (Ilfochrome). 19⅝ x 13³⁄₁₆ in. (499 x 334 mm.). From an edition of 10.

FAMILY COLLISION

52. *Ethereal Boy*. 1981. Silver-dye-bleach print (Cibachrome). 6½ x 9⁷⁄₁₆ in. (166 x 240 mm.). From an edition of 10.

53. *Folded Man*. 1981. Silver-dye-bleach print (Cibachrome). 6¹¹⁄₁₆ x 9⁷⁄₁₆ in. (169 x 240 mm.). Edition 1/10.

54. *Boy/Bottle Green Background*. 1981. Silver-dye-bleach print (Cibachrome). 6⁷⁄₁₆ x 9⁹⁄₁₆ in. (164 x 243 mm.). Edition 2/10.

55. *Blonde Falling*. (1981). Silver-dye-bleach print (Cibachrome). 9⁹⁄₁₆ x 6½ in. (243 x 166 mm.). From an edition of 10.

56. *Floating Boy / Red Shoes*. 1981. Silver-dye-bleach print (Cibachrome). 9½ x 6½ in. (241 x 166 mm.). From an edition of 10.

57. *Blue Ground / Tumbling Family / Overlapped*. 1981. Silver-dye-bleach print (Cibachrome). 6½ x 9⁹⁄₁₆ in. (166 x 243 mm.). From an edition of 10.

58. *Folded Man / Bottom Pool*. 1981. Silver-dye-bleach print (Cibachrome). 6⅝ x 9⁹⁄₁₆ in. (169 x 243 mm.). Edition 1/10.

59. *Untitled*. 1981. Silver-dye-bleach print (Cibachrome). 9⁹⁄₁₆ x 6⅝ in. (243 x 166 mm.). From an edition of 10.

60. *Father / Son / Cut Out*. (1981). Gelatin silver print. 15½ x 23 in. (394 x 584 mm.). From an edition of 10. Collection Carroll Dunham, New York.

61. *Family Collision (Legs)*. (1981). Gelatin silver print. 15½ x 23 in. (394 x 584 mm.). From an edition of 10. Collection Carroll Dunham, New York.

62. *Horizontal Family (Baby Falling)*. (1981). Gelatin silver print. 15½ x 23 in. (394 x 584 mm.). From an edition of 10. Collection Carroll Dunham, New York.

63. *Boy (Floating) (Sand)*. (1981). Gelatin silver print. 15½ x 22⅝ in. (394 x 575 mm.). From an edition of 10. Collection Carroll Dunham, New York.

64. *Son Waving to Father*. (1981). Gelatin silver print. 12½ x 22½ in. (318 x 572 mm.). From an edition of 10. Collection Carroll Dunham, New York.

65. *Family (Shadows)*. (1981). Gelatin silver print. 15½ x 22¾ in. (394 x 578 mm.). From an edition of 10. Collection Carroll Dunham, New York.

66. *Woman / Heels (Floating on Back)*. 1981. Gelatin silver print. 17 x 23⅝ in. (430 x 600 mm.). From an edition of 10.

67. *Man Floating (Arms Outstretched)*. 1981. Gelatin silver print. 15⅜ x 22½ in. (390 x 577 mm.). From an edition of 10.

BALLET

68. *Ballet Stage*. 1983 (printed 1997). Silver-dye-bleach print (Ilfochrome) (previously printed as chromogenic color print [Ektacolor]). 28⅛ x 35½ in. (714 x 903 mm.). Edition 2/5.

69. *Waltz of the Snowflakes*. 1983 (printed 1997). Silver-dye-bleach print (Ilfochrome) (previously printed as chromogenic color print [Ektacolor]). 26¾ x 40 in. (679 x 1015 mm.). Edition 3/5.

70. *Untitled*. 1983 (printed 1997). Silver-dye-bleach print (Ilfochrome) (previously printed as chromogenic color print [Ektacolor]). 36 x 30 in. (915 x 762 mm.). Edition 3/5.

COLOR-COORDINATED INTERIORS

71. *Green Kitchen*. (1982). Chromogenic color print (Ektacolor). 38 x 49½ in. (965 x 1257 mm.). Edition 2/5.

72. *Coral Living Room with Lilies*. (1983). Chromogenic color print (Ektacolor). 49½ x 39½ in. (1257 x 1002 mm.). Edition 1/5.

73. *Yellow Bathroom*. (1983, printed 1997). Silver-dye-bleach print (Ilfochrome). 40 x 29¼ in. Edition 2/5.

TOURISM

74. *Tourism: Parthenon*. (1984, printed 1997). Silver-dye-bleach print (Ilfochrome). 40 x 60 in. (1015 x 1524 mm.). Unique in this size. Collection F. C. Gundlach, Hamburg. Exhibition print.

75. *Tourism: Las Vegas*. (1984, printed 1997). Silver-dye-bleach print (Ilfochrome). 40 x 60 in. (1015 x 1524 mm.). Unique in this size. Galerie Carola Mösch, Berlin. Exhibition print.

76. *Tourism: Barcelona*. (1984, printed 1987). Silver-dye-bleach print (Cibachrome). 60⅜ x 40⅛ in. (1531 x 1019 mm.). Unique in this size. The Baltimore Museum of Art: Purchased with funds from the Polaroid Foundation. BMA 1987.138.

77. *Tourism: Pyramids*. (1984, printed 1997). Silver-dye-bleach print (Ilfochrome). 40 x 60 in. (1015 x 1524 mm.). Unique in this size. Collection F. C. Gundlach, Hamburg. Exhibition print.

78. *Tourism: Pink Stonehenge*. (1984, printed 1997). Silver-dye-bleach print (Ilfochrome). 40 x 60 in. (1015 x 1524 mm.). Unique in this size. Whereabouts unknown. Exhibition print.

ACTUAL PHOTOS

79–129. "Actual Photos." In collaboration with Allan McCollum. 1985. Fifty-one silver-dye-bleach prints (Cibachromes). 6¼ x 9¼ in. (159 x 235 mm.). From an edition of 10 (each numbered differently within the edition).

VENTRILOQUISM

130. *The Frenchman (Mickey)*. 1987. Silver-dye-bleach print (Cibachrome). 35 x 25 in. (888 x 641 mm.). Edition 4/5. Collection Metro Pictures, New York.

131. *English Lady*. 1987. Silver-dye-bleach print (Cibachrome). 35 x 25 in. (888 x 634 mm.). Edition 4/5. Collection Eileen and Michael Cohen, New York.

132. *Pancho*. 1988. Silver-dye-bleach print (Cibachrome). 35 x 25 in. (888 x 634 mm.). Edition 2/5.

133. *Jane*. 1988. Silver-dye-bleach print (Cibachrome). 35 x 25 in. (888 x 634 mm.). Edition 2/5.

134. *Girl Vent Press Shots*. 1988. Twenty-five approx. 10 x 8 in. (253 x 202 mm.) and one 68 x 48 in. (1726 x 1219 mm.). Silver-dye-bleach prints (Cibachromes). Edition 1/5. Private Collection, New York.

WALKING AND LYING OBJECTS

135. *Walking Camera I (Jimmy the Camera)*. 1987. Gelatin silver print. 83¼ x 47¼ in. (2114 x 1200 mm.). Edition 5/5.

136. *Walking Purse*. 1989. Gelatin silver print. 84 x 48 in. (2132 x 1219 mm.). Edition 3/5. Collection Esme Lisdan, New York.

137. *Walking Cake*. 1989. Gelatin silver print. 84 x 48 in. (2132 x 1219 mm.). Edition 4/5. Collection R. Learsy.

138. *Walking House*. 1989. Gelatin silver print. 83¼ x 47⅜ in. (2114 x 1203 mm.). Edition 5/5. The Museum of Modern Art, New York, Richard E. and Christie Salomon Fund and The Family of Man Fund, 194.92.

139. *Walking Hourglass*. 1989. Gelatin silver print. 84 x 48 in. (2132 x 1219 mm.). Edition 1/5. The Museum of Contemporary Art, Los Angeles: Purchased with funds provided by Councilman Joel Wachs.

140. *Lying Perfume Bottle*. 1990. Silver-dye-bleach print (Cibachrome). 48 x 84 in. (1219 x 2132 mm.). Edition 2/5. Collection the Estee Lauder Companies, Inc.

141. *Bending Globe*. 1991. Silver-dye-bleach print (Cibachrome). 48 x 84 in. (1219 x 2132 mm.). AP, from an edition of 5.

142. *Walking Gun*. 1991. Gelatin silver print. 48 x 84 in. (1219 x 2132 mm.). Edition 1/5. Collection Sondra Gilman and Celso Gonzalez-Falla, New York.

143. *Magnum Opus (The Bye-Bye)*. 1991. Gelatin silver print. 101¼ x 240⅝ in. (2571 x 6095 mm.). Unique.

CLOTHES MAKE THE MAN

144. *Clothes Make the Man (don't I know it)*. 1990–1991. Mixed media. 39½ x 12 x 15 in. (100.4 x 30.5 x 38.2 cm.). Unique.

145. *Clothes Make the Man (don't ask)*. 1992. Mixed media. 39½ x 12 x 15 in. (100.4 x 30.5 x 38.2 cm.) Unique.

THE MUSIC OF REGRET

146. *The Music of Regret I*. 1994. Gelatin silver print. 60 x 40 in. (1524 x 1015 mm.). From an edition of 5. Exhibition print.

147. *The Music of Regret III*. 1994. Gelatin silver print. 60 x 40 in. (1524 x 1015 mm.). Edition 2/5. Collection Alison and Alan Schwartz, Toronto.

148. *The Music of Regret IV*. 1994. Gelatin silver print. 84 x 84 in. (2132 x 2132 mm.). Edition 1/5.

149. *The Music of Regret IV (Color)*. 1994. Silver-dye bleach print (Ilfochrome). 19½ x 19½ in. (495 x 495 mm.). Edition 1/5. Collection Steven Scott, Baltimore.

THE UMBRELLAS OF CHERBOURG

150. *The Umbrellas of Cherbourg*. 1996. Mixed media installation. Dimensions site-specific. Unique.

BLACK BATHROOMS

151. *Black Bathroom/View through Window, March 26, 1997*. 1997. Silver-dye bleach print (Ilfochrome). 40 x 30 in. (1017 x 763 mm.). Edition 1/5.

152. *Black Bathroom, April 16, 1997*. 1997. Silver-dye bleach print (Ilfochrome). 30 x 40 in. (763 x 1017 mm.). Edition 1/5.

SELECTED BIBLIOGRAPHY

1979

Lifson, Ben. "Robert Frank and the Track of Life." *The Village Voice* (February 12, 1979): 85.

1980

Grundberg, Andy. "Art Breakers: N.Y.'s Emerging Artists." *The Soho Weekly News* (September 17–23, 1980): 42–43.

Plous, Phyllis, and Steven Cortright. *Invented Images* (exhibition catalogue). Santa Barbara: UCSB Art Museum, University of California, Santa Barbara, 1980.

Simmons, Laurie. "Sam and Dottie Dance" (portfolio). *Real Life Magazine* no. 4 (summer 1980): 22–23.

1981

Grundberg, Andy. "Mixing Art and Commerce." *The New York Times*, May 24, 1981, sec. D, p. 25.

Grundberg, Andy. "Water Buoyed." *The Soho Weekly News* (May 6, 1981): 47, 48.

Klein, Michael R. "Laurie Simmons." *Arts Magazine* 55, no. 9 (May 1981): 4.

Kotik, Charlotta et al. *Figures: Forms and Expressions* (exhibition catalogue). Buffalo, N.Y.: Albright-Knox Art Gallery, 1981.

"Pictures That Tell the Truth by Making It Up." *Photography Year / 1981 Edition*. Alexandria, Va.: Time-Life Books, 1981: 12–23.

Simmons, Laurie. "Underwater Photographs" (portfolio). Introduction by Carroll Dunham. *Sun and Moon* no. 11 (spring 1981): 41–45, also front and back cover illustrations.

Smith, Roberta. "Mark Rothko's Surrealistic Billows." *The Village Voice* 26, no. 19 (May 6–12, 1981).

Solomon-Godeau, Abigail. "Conventional Pictures." *The Print Collector's Newsletter* 12, pt. 5 (November/December 1981): 138–40.

1982

Klonarides, Carole Ann, and Michael Owen, directors. "Laurie Simmons" in *Crossover Series: Cindy Sherman, Richard Prince, Laurie Simmons*. New York: The Artists Television Network, 1982. Videocassette.

Marincola, Paula. *Image Scavengers: Photography* (exhibition catalogue). Philadelphia: Institute of Contemporary Art, University of Pennsylvania, 1982.

Smith, Roberta. *Body Language: Figurative Aspects of Recent Art* (exhibition catalogue). Cambridge, Ma.:

Hayden Gallery, Massachusetts Institute of Technology, 1982.

Stewart, Albert. *New New York* (exhibition catalogue). Tallahassee, Fla: University Fine Arts Galleries, Florida State University, 1982.

1983

Carré, Dominique. "Images Fabriquées." *Les Photographiques* (November 1983): 3.

Grundberg, Andy. "Seeing the World as Artificial." *The New York Times*, March 27, 1983, sec. H, pp. 32 & 35.

Lichtenstein, Therese. "Laurie Simmons." *Arts Magazine* 57, no. 10 (June 1983): 21.

Linker, Kate. "On Artificiality." *Flash Art* no. 111 (March 1983): 33–35.

Onorato, Ronald J. "The Photography of Laurie Simmons." *Arts Magazine* 57, no. 8 (April 1983): 122–23.

Simmons, Laurie. *Laurie Simmons: In and Around the House, Photographs 1976–1979* (artist's book). Buffalo, N.Y.: CEPA Gallery, 1983.

Solomon-Godeau, Abigail. *In Plato's Cave* (exhibition catalogue). New York: Marlborough Gallery, 1983.

Squiers, Carol. "Undressing the Issues." *The Village Voice* (April 5, 1983): 81.

1984

Baudrillard, Jean. "The Precession of Simulacra." *Art After Modernism: Rethinking Representation*. Edited by Brian Wallis. New York: The New Museum of Contemporary Art, 1984.

Brooks, Rosetta. "Guys and Dolls." *ZG Magazine* no. 111 (summer 1984): 7–9, and front cover illustration.

Lippard, Lucy. "Cool Wave." *The Village Voice* (July 10, 1984).

Simmons, Laurie. "Tourism" (portfolio). *The Paris Review* 26, no. 93 (fall 1984): 93–101.

Smith, Roberta. "Exercises for the Figure." *The Village Voice* (November 20, 1984): 120.

1985

Biegler, Beth. "Surrogates and Stereotypes" (interview with Allan McCollum and Laurie Simmons). *East Village Eye* (December 1985/January 1986): 43, 64.

Brooks, Rosetta. "From the Night of Consumerism to the Dawn of Simulation." *Artforum* 23, no. 5 (February 1985): 76–81.

Heartney, Eleanor. "Laurie Simmons." *ARTnews* 84, no. 2 (February 1985): 143–44.

Linker, Kate. "Laurie Simmons." *Artforum* 23, no. 7 (March 1985): 95–96.

Linker, Kate. "Ex-posing the Female Model or, on the Woman Who Poses for Money." *Parachute* no. 40 (September/November 1985): 15–17, and cover illustration.

1985 Biennial Exhibition (exhibition catalogue). New York: Whitney Museum of American Art, 1985.

Rinder, Larry. "Laurie Simmons and Allan McCollum." *Flash Art* no. 125 (December 1985/January 1986): 44–45.

Simmons, Laurie. "Tourism" (portfolio). *Wedge* no. 7/8 (winter/spring 1985): 82–85.

Town, Elke. *Subjects and Subject Matter* (exhibition catalogue). London, Ontario: London Regional Art Gallery, 1985.

1986
Barendse, Henry. *The Fashionable Image: Unconventional Fashion Photography*. Essay by Carol Squiers (exhibition catalogue). Charlotte, N.C.: Mint Museum Department of Art, 1986.

Feinstein, Roni. *Photographic Fictions* (exhibition catalogue). Stamford, Conn.: Whitney Museum of American Art, Fairfield County, 1986.

Gagnon, Paulette. *La magie de l'image* (exhibition catalogue). Montreal: Musée d'Art Contemporain, 1986.

Relyea, Lane, and Connie Fitzsimmons. *Remembrance of Things Past* (collected writings and exhibition catalogue). Long Beach, Calif.: Long Beach Museum of Art, 1986.

Saltz, Jerry. *Beyond Boundaries: New York's New Art*. Additional essays by Roberta Smith and Peter Halley. New York: Alfred van der Marck Editions, 1986.

Smith, Roberta. "Allan McCollum and Laurie Simmons at Nature Morte." *Art in America* 74, no. 1 (January 1986): 139.

Squiers, Carol. "'Les Infos du Paradis' Photo Opportunity: Art Photography and the Commercial Arena." *Parkett* no. 11 (December 1986): 125–27.

Waterlow, Nick. *Origins, Originality + Beyond* (exhibition catalogue). Sydney, Australia: Art Gallery of New South Wales, 1986.

1987
Brunon, Bernard. *Contemporary Photographic Portraiture* (exhibition catalogue). Lyon, France: Ville de Lyon, Octobre des Arts, 1987.

Celant, Germano, Kate Linker, Lars Nittve, and Craig Owens. *Implosion: A Postmodern Perspective* (exhibition catalogue). Stockholm: Moderna Museet, 1987.

Goldwater, Marge. *Past/Imperfect: Eric Fischl, Vernon Fisher, Laurie Simmons* (exhibition catalogue). Minneapolis: Walker Art Center, 1987.

Grundberg, Andy, and Kathleen McCarthy Gauss. *Photography and Art: Interactions Since 1946* (exhibition catalogue). Fort Lauderdale, Fla.: Museum of Art, 1987.

Heiferman, Marvin, and Joseph Jacobs. *This is Not a Photograph: Twenty Years of Large-Scale Photography, 1966–1986* (exhibition catalogue). Sarasota, Fla.: The John and Mable Ringling Museum of Art Foundation, Inc., 1987.

Hoy, Anne H. *Fabrications: Staged, Altered, and Appropriated Photographs*. New York: Abbeville Press, 1987.

Interview by Cindy Sherman. *Laurie Simmons*. Tokyo: Parco Vision Contemporary, 1987.

Simmons, Laurie. *Laurie Simmons: Water Ballet/Family Collision* (artist's book). Minneapolis: Walker Art Center, 1987.

Simmons, Laurie. "Ventriloquism" (portfolio). *Artforum* 26, no. 4 (December 1987): 93–99.

1988
Akai, Shigeki, ed. *Nude 2*. Essay by Shuhei Takahashi. Tokyo: Asahi Shuppen-Sha, 1988.

Carter, Curtis L. *Photography on the Edge* (exhibition catalogue). Essay by Noël Carroll. Milwaukee, Wis.: The Patrick and Beatrice Haggerty Museum of Art, Marquette University, 1988.

Collins, Tricia, and Richard Milazzo. *Media Post Media* (exhibition catalogue). New York: Scott Hanson Gallery, 1988.

Hartshorn, Willis. *2 to Tango: Collaboration in Recent American Photography* (exhibition brochure). New York: International Center of Photography, 1988.

Heartney, Eleanor. "Laurie Simmons at Metro Pictures." *Art in America* 76, no. 6 (June 1988): 160–61.

Smith, Roberta. "Art: 'Media Post Media,' a Show of 19 Women." *The New York Times*, January 15, 1988, sec. C, p. 24.

Springfeldt, Björn, Bo Nilsson, Jean-François Lyotard et al. *MATRIS* (exhibition catalogue). Malmö, Sweden: Malmö Konsthall, 1988.

Woodward, Richard B. "Laurie Simmons, Metro Pictures." *ARTnews* 87, no. 5 (May 1988): 161.

1989
Ball, Edward. "'The Beautiful Language of My Century' From the Situationists to the Simulationists." *Arts Magazine* 63, no. 5 (January 1989): 65–72.

Cameron, Dan. "Recent Work by Laurie Simmons: Informed by Uneasiness and Indefinable Malaise." *Flash Art*, no. 149 (November/December 1989): 116–18.

Heiferman, Marvin, and Lisa Phillips with John G. Hanhardt. *Image World: Art and Media Culture* (exhibition catalogue). New York: Whitney Museum of American Art, 1989.

Jacob, Mary Jane, Ann Goldstein, Anne Rorimer et al. *A Forest of Signs: Art in the Crisis of Representation* (exhibition catalogue). Los Angeles: The Museum of Contemporary Art, 1989.

Jones, Ronald. *Laurie Simmons* (exhibition catalogue). Cologne: Jablonka Galerie, 1989.

Kozloff, Max. "Hapless Figures in an Artificial Storm." *Artforum* 28, no. 3 (November 1989): 131–36.

Kwon, Miwon. *Suburban Home Life: Tracking the American Dream* (exhibition catalogue). New York: Whitney Museum of American Art, Downtown at Federal Reserve Plaza, 1989.

Rosen, Randy, and Catherine C. Brawer. *Making Their Mark: Women Artists Move into the Mainstream, 1970–1985* (exhibition catalogue). Cincinnati: Cincinnati Museum of Art, 1989.

Rosenblum, Naomi. *A World History of Photography*. 2nd edition. New York: Abbeville Press, 1989.

Saltz, Jerry. "Laurie Simmons at Metro Pictures." *Art Today* 1, no. 2. New York: Arts Video News Services, Inc., December 1989. Videocassette.

Smith, Joshua. *The Photography of Invention: American Pictures of the 1980s* (exhibition catalogue). Washington, D.C.: National Museum of American Art, Smithsonian Institution, 1989.

Sultan, Terrie. *Surrogate Selves: David Levinthal, Cindy Sherman, Laurie Simmons* (exhibition pamphlet). Washington, D.C.: The Corcoran Gallery of Art, 1989.

Uusitorppa, Harri. "Kun keinotekoinen on aitoa." *Helsingin Sanomat* no. 7, 8 (huhtikuuta 1989): 73–76.

Woodward, Richard B. "Taking Toys Seriously: Mini-Movement or Sideshow?" *The New York Times*, February 26, 1989, Arts & Leisure sec., pp. 39, 40.

1990
Adcock, Craig. "Laurie Simmons." *Tema Celeste* 25, no. 2 (April/June 1990): 66.

Albanese, Dara. "Context of Scale." Interview with Laurie Simmons. *Cover* (May 1990): 16–17.

Amanshauser, Hildegund, and Dan Cameron. *UMWEG MODERNE Modern Detour: R. M. Fischer, Peter Halley, Laurie Simmons* (exhibition catalogue). Vienna: Wiener Secession, 1990.

Bartman, William S., ed. *Jimmy DeSana*. Interview by Laurie Simmons. Essay by Roberta Smith. Los Angeles: A.R.T. Press, 1990.

Berggren, Irene. "Blickens tillintetgörelse." *Bildtidningen*, no. 4 (April 1990): 10–23.

Cameron, Dan. *Laurie Simmons* (exhibition catalogue). San Jose, Calif.: San Jose Museum of Art, 1990.

Gianelli, Ida. *Sguardo di Medusa* (exhibition catalogue). Milan: Castello di Rivoli, 1991.

Grande, Vincenç Altaió-Chantal, Dan Cameron, José Carlos Cataño et al. *To Be and Not to Be* (exhibition catalogue). Barcelona: Centre d'Art Santa Mònica, 1990.

Grundberg, Andy. *Crisis of the Real: Writings on Photography, 1974–1989*. New York: Aperture Foundation, Inc., 1990. Reprint of "Water Buoyed." *The Soho Weekly News* (May 6, 1981).

Hayt-Atkins, Elizabeth. "Laurie Simmons." *ARTnews* 89, no. 3 (March 1990): 173–74.

Lipton, Eunice et al. *The Decade Show: Frameworks of Identity in the 1980s* (exhibition catalogue). New York: Museum of Contemporary Hispanic Art, The New Museum of Contemporary Art, and the Studio Museum in Harlem, 1990.

Omori, Takao. "Ningyo tachino hakujitsuu: Laurie Simmons." *Mizue*, no. 957 (winter 1990): 40–53.

Spector, Nancy. "Laurie Simmons." *Contemporanea* 3, no. 3 (March 1990): 88.

Sullivan, Constance, ed. *Women Photographers*. Essay by Eugenia Parry Janis. New York: Harry N. Abrams, 1990.

Tanaka, Hiroko. *Art is Beautiful*. Japan: Kawade Shoboh Shinsya, 1990.

1991
Amanshauser, Hildegund, Dan Cameron, R. M. Fischer, Peter Halley, Laurie Simmons et al. *Kunst in New York* (*UMWEG MODERNE Modern Detour* symposium catalogue). Vienna: Wiener Secession, 1991.

Armstrong, Richard, John G. Hanhardt, Richard Marshall, and Lisa Phillips. *1991 Biennial Exhibition* (exhibition catalogue). New York: Whitney Museum of American Art, 1991.

Ballerini, Julia. *The Surrogate Figure: Intercepted Identities in Contemporary Photography* (exhibition catalogue). Woodstock, N.Y.: The Center for Photography at Woodstock, 1991.

Blackwood, Michael, producer and director. *After Modernism: The Dilemma of Influence*. New York: Michael Blackwood Productions, Inc., 1992. Videocassette.

Galassi, Peter. *Pleasures and Terrors of Domestic Comfort* (exhibition catalogue). New York: The Museum of Modern Art, 1991.

Hagen, Charles. "Constructing a Universe of Chimeras." *The New York Times*, October 25, 1991, sec. C, p. 28.

Tomidy, Paul, Ronald Jones, and Peter Schjeldahl. *de-Persona* (exhibition catalogue). Oakland, Calif.: The Oakland Museum, 1991.

1992

Canning, Susan M. *The Order of Things: Toward a Politics of Still Life* (exhibition catalogue). Hartford, Conn.: Widener Gallery at Trinity College and Real Art Ways, 1992.

Coller, Barbara, and Donald Kuspit. *The Edge of Childhood* (exhibition catalogue). Huntington, N.Y.: The Heckscher Museum, 1992.

Faust, Gretchen. "Laurie Simmons." *Arts Magazine* 66, no. 5 (January 1992): 86.

Felau, Fred. *Hollywood Hollywood* (exhibition catalogue). Essays by Anne Friedberg, Michael Lassell, and David Bobbins. Pasadena, Calif.: Pasadena Art Alliance, 1992.

Gardner, Paul. "Do Titles Really Matter?" *ARTnews* 91, no. 2 (February 1992): 92–97.

Jenkins, Nicholas. "Laurie Simmons." *ARTnews* 91, no. 1 (January 1992): 119.

1993

Burns, Victoria Espy. *Vivid: Intense Images by American Photographers*. Milan: Federico Motta Editore S.p.A., 1993.

Carter, Curtis L. *Dolls in Contemporary Art: A Metaphor of Personal Identity*. Milwaukee: The Patrick and Beatrice Haggerty Museum of Art, Marquette University, 1993.

Kelley, Mike, ed. *The Uncanny* (exhibition catalogue). Arnhem, The Netherlands: Gemeentemuseum, 1993.

Phillips, Lisa. *Photoplay: Works from the Chase Manhattan Collection* (exhibition catalogue). New York: The Chase Manhattan Corporation, 1993.

Thorkildsen, Åsmund, ed. *Louise Lawler, Cindy Sherman, Laurie Simmons* (exhibition catalogue). Oslo: Kunstnernes Hus, 1993.

1994

Bartman, William S., and Rodney Sappington, eds. *Laurie Simmons*. Interview by Sarah Charlesworth. Los Angeles: A.R.T. Press, 1994.

Decter, Joshua. "Stupidity as Destiny: American Idiot Culture." *Flash Art* 27, no. 178 (October 1994): 72–76.

Gardner, Paul. "Light, Canvas, Action: When Artists Go to the Movies." *ARTnews* 93, no. 10 (December 1994): 124–29.

Hagen, Charles. "Laurie Simmons." *The New York Times*, May 6, 1994, sec. C, p. 19.

Vine, Richard. "Laurie Simmons at Metro Pictures." *Art in America* 82, no. 12 (December 1994): 95.

1995

Die Muse: Transforming the Image of Women in Contemporary Art (exhibition catalogue). Paris: The Salzburger Festival, Galerie Thaddeus Ropac, 1995.

Elger, Deitmar, and Luise Horn. *McCollum / Simmons: Actual Photos* (published on the occasion of exhibition at Sprengel Museum Hannover and Kunstraum München). Ostfildern, Germany: Cantz Verlag, 1995.

Hagen, Charles. "Two Teams That Challenge Tradition." *The New York Times*, June 16, 1995, sec. C, p. 24.

Pultz, John. *The Body and the Lens: Photography 1839 to the Present*. New York: Harry N. Abrams, 1995.

1996

Barnes, Lucinda et al., eds. *Between Artists: Twelve Contemporary American Artists Interview Twelve Contemporary American Artists*. Los Angeles: A.R.T. Press, 1996.

Cattini, Sandra. *Le Printemps de Cahors: Photographie & Arts Visuels 1996* (exhibition catalogue). Paris: Marval, 1996.

Fenz, Werner and Reinhard Braun. *RADIKALE BILDER. 2. Österreichische Triennale zur Fotografie 1996 / RADICAL IMAGES. 2nd Austrian Triennial on Photography 1996* (exhibition catalogue, 2 vols.). Graz: Neue Galerie am Landesmuseum Joanneum and Camera Austria, 1996.

Picazo, Gloria and Juan Vicente Aliaga. *FRAGMENTS: Proposta per a una col·lecció de fotografia contemporània* (exhibition catalogue). Barcelona: Museu d'Art Contemporani de Barcelona, 1996.

Swartz, Anne. *Laurie Simmons: Icons of Feminism* (exhibition catalogue). Savannah, Ga.: The Savannah College of Art and Design, 1996.

Weintraub, Linda. "Laurie Simmons." *Art on the Edge and Over: Searching for Art's Meaning in Contemporary Society, 1970s–1990s*. Litchfield, Ct.: Art Insights, Inc., 1996: 34–38.

Yablonsky, Linda. "Laurie Simmons" (interview). *Bomb*, no. 57 (fall 1996): 18–23.

1997

Hirsch, Robert. *Exploring Color Photography*. 3rd edition. Madison, Wi.: Brown & Benchmark Publishers, 1997.

Muniz, Vik. *Making it Real*. Introduction by Luc Sante (exhibition catalogue). New York: Independent Curators, Incorporated, 1997.

Simmons, Laurie, director. *Laurie Simmons: Filmstrip*. New York: Bill Bartman as a project of A.R.T. Press, Inc., 1997. Videocassette.

Literary Credits

Pages 71–72, excerpt from Susanna Moore, *My Old Sweetheart* (New York: Penguin Books, 1982), pp. 3–7, copyright ©1992 by Susanna Moore, reprinted with the permission of The Wylie Agency, Inc.; p. 78, Garrett Kalleberg, *The Garden*, printed by permission of the poet; p. 92, Jimmy DeSana, "A Simple Shoe," reprinted from *Quotations from Jimmy de Sana* [sic] (New York: Pat Hearn Gallery, 1988); p. 106, excerpt from John Waters, "Ladies and Gentlemen . . . the Nicest Kids in Town!," *Crackpot: The Obsessions of John Waters* (New York: Macmillan Publishing Company, 1983), p. 88, reprinted with the permission of Simon & Schuster. Copyright © 1986 by John Waters.

Photography Credits

All photographs of works by Laurie Simmons provided by the artist except as noted. Other credits: p. 24, Scala/Art Resource, New York; p. 26, Courtesy the artist and Lisson Gallery, London; p. 33, Estate of Jimmy DeSana, Courtesy Pat Hearn Gallery, New York; p. 34, © 1948, Universal Pictures Co., Inc., Photofest, New York; p. 50, The Baltimore Museum of Art: Gift of Steven Scott, in honor of the 25th Anniversary of the Print and Drawing Society, BMA 1993.154; p. 59, The Baltimore Museum of Art: Purchased with exchange funds from the Edward Joseph Gallagher III Memorial Collection; and Partial Gift of George H. Dalsheimer, Baltimore, BMA 1988.435, ©1997 Artists Rights Society (ARS), New York/ADAGP/Man Ray Trust, Paris; p.60 and 107, Brian Forrest; p. 100, copy print, ©1997 The Museum of Modern Art, New York.

Designed by The Grenfell Press/Produced by Red Ink Productions

Printed May 1997, in an edition of 2,500 copies

Composed in Perpetua. Printed on acid free Hannoato paper

Self Portrait, outtake from *The New York Times Magazine* fashion shoot "The Perfect Companion." 1994.